LOST COUNTRY HOUSES OF
DERBYSHIRE

MAXWELL CRAVEN

AMBERLEY

To Mick and Gill Stanley
In memory of past endeavours

This edition first published 2024

Amberley Publishing
The Hill, Stroud
Gloucestershire GL5 4EP

www.amberley-books.com

British Library Cataloguing in Publication Data.
A catalogue record for this book is available from the British Library.

ISBN 978 1 3981 1142 4 (print)
ISBN 978 1 3981 1143 1 (ebook)

Typesetting by SJmagic DESIGN SERVICES, India.
Printed in Great Britain.

Contents

Acknowledgements

The author stands in debt to a large number of people in the preparation of this book, not least those who helped so generously in various ways towards the three editions of *The Derbyshire Country House,* to which my friend and former colleague Mick Stanley provided strong support, not to mention his important geological input relating to building stone and its sources. With his wife, Gillian, and my wife, Carole, we visited most of these sites whilst compiling the first edition of *The Derbyshire Country House 1979–1983,* taking black and white photographs and colour slides to aid lecturing. Garry Plant, publisher of Derbyshire's *Country Images Magazine,* encouraged me to initiate an as yet uncompleted series of monthly articles, each devoted to one house (not all country ones, however) which allowed me to re-research most of them, and for this I am extraordinarily grateful. Nor can one omit the kindness of Amberley Publishing and the helpfulness of Nick Grant in particular, constrained as they were by the Covid-19 pandemic, still (it is to be hoped) in its death throes as this book was prepared for publication.

Former colleagues at Derby Museum were most kind in allowing me to continue to use images originally made available for *The Derbyshire Country House* and the staff at the Derby Local Studies Library, not to mention the County Library Service, especially the branches at Glossop, Buxton, Alfreton and Chesterfield, all of whom have been extremely helpful over several decades, not to mention many years of assistance from both the Derbyshire Record Office and former, much-missed, County Museum Service. The Royal Commission on Historic Monuments, English Heritage/Historic England and the former National Monument Record have been a great help over nearly forty years. Viv Irish, long editor of *Derbyshire Life,* was also most helpful with finding images I could use.

Heartfelt thanks are also due to the late L. F. Cave-Browne-Cave, Lady Chichester, David Coke-Steel, Matthew Constantine, the late Sir Howard Colvin, Richard Craven, James Darwin, Nicolas Davie-Thornhill, Susan Ellis, the late Sir John Every, Bt., the late Don Farnsworth, Alan Gifford, John Harvey, Mark Higginson, the late Betty Hughes, John Legg, Godfrey Meynell MBE, the late Ambrose Moore, the late B. F. J. Pardoe, the late Lt. Col. T. H. Pares, Roger Pegg, the late Edward Saunders, the late Viscount Scarsdale, the late Sir Reresby Sitwell, Bt., Robert Innes-Smith, Gladwyn Turbutt, Cliff Williams and many others, without whom this book would not have been remotely possible. Others who have kindly made illustrations available are acknowledged with the relevant picture. Finally, my most enduring thanks go to my wife, Carole, for forbearance, transport, collation and innumerable other assistance freely given and most warmly appreciated.

The author would also be most pleased to hear, too, from anyone who can throw further light upon any of the houses mentioned, or others omitted (this mainly due to the paucity of illustrations), or are able to offer corrections, for any mistakes are entirely my own, and in a work of this scope, impossible wholly to avoid.

Introduction

Sir Roy Strong, in his introduction to the catalogue of *The Destruction of the Country House* held at the Victoria and Albert Museum in 1974, wrote of the way that, in the British countryside, we then took for granted our country houses. 'Like our parish churches,' he wrote, 'the country houses seem always to have been there, since time immemorial part of the fabric of our heritage.' It would seem invidious to add that in 1974 we also took for granted the vicarage, the pub, the shop, the post office and the pleasure of sharing a stirrup cup with the meet on Boxing Day, all institutions, if anything, even more under threat today than the country house.

Throughout the twentieth century, we have suffered an alarming loss of such buildings, their settings, contents, and the way of life they supported. Their destruction represents one of the greatest losses of our art history – architecture, craftsmanship, fine art, furniture, sculpture, archives – all. The 1974 V&A exhibition changed all that, and the tide of destruction was gradually rolled back from 1979, aided by the progressive diminution of the personal tax burden (a trend regrettably reversed in the present century), which once more began to make the possibility of living in a large house in the country a viable proposition. This, in turn, led to a renewed interest in traditional trades and provided a wider choice over employment in the countryside.

In Derbyshire in the years since 1969, when listed building consent was first required prior to the demolition of the listed building, only eight Derbyshire houses have been lost, and only one – the shameful saga of Burnaston House – was of major importance. From 1945 to 1968 no fewer than twenty-seven were destroyed. Before that, the destruction was even worse. The figures speak for themselves. Derbyshire's worst year – its *annus horribilis* – was actually 1938 (a decade before the Act that provided for a statutory list of buildings of architectural and historic importance) when eight houses fell to the contractor's ball and chain. Thereafter destruction was more evenly spread, 1957 being the second worst year with five serious losses and four in 1964. The 1968 Town and Country Planning Act and the 1974 exhibition together were thus a watershed, and the figures repeat for most lowland counties.

Yet for all this, country houses have been destroyed right through the last millennium for a wide variety of reasons; there have always been losses, as this book shows. The most common reason for the destruction of an important house before 1919 – apart from the random but ever-present threat of fire – was unusually the desire of the owner to improve the standard of his accommodation, or to expand it, often commensurate with a rise in status. In the nineteenth century, an agricultural boom, which lasted throughout the middle years until around 1873, coupled with a superfluity of labour, caused households to expand,

and more and better standards of service accommodation was required. Some owners met these needs by enlarging, as with Chatsworth in the late seventeenth century, or Renishaw in the late eighteenth, others by demolition and replacement, as with Kedleston – twice within sixty years in the eighteenth century. In 1516, Markeaton Hall was sold by the poverty-stricken Lords Audley to the upwardly mobile Mundys, who built a new house. That, in turn, was replaced by a new Georgian seat, designed by local mason-turned-architect James Denstone of Derby in 1755, when the Mundys wanted something more modern (although not necessarily larger). Even then, it later underwent two piecemeal enlargements. Other factors include the amalgamation of estates, war (especially the English Civil War), plague, urban expansion, mining and quarrying, lack of tenants, land requisition for infrastructure (like Derwent and Ogston Reservoirs), financial pressure and taxation (Lloyd George's death duties especially), local authority neglect, philistinism and sheer bloody mindedness, as with the magical Repton Park.

The demolition of houses, therefore, can be seen as a continuing process of loss and renewal until the last century, when a host of new factors came into play. Losses accelerated alarmingly and little in terms of renewal was on offer. It is this last factor which, until the 1980s, was most worrying, as a substantial and largely unsung portion of our cultural and artistic heritage was swept away in a holocaust of destruction over some sixty-five years, 1919–74, when seventy-one out of the county total of 242 lost houses were destroyed, over one-third of the total over something like 500 years.

This book aims to give a brief visual record of the majority of the losses, as far as the available images permit, with brief descriptive and historical captions, and may be viewed as a locally complementary work to add fine detail to Giles Worsley's *The Lost Houses of Britain* (Aurum Press/Country Life, 2002). I have concentrated on country houses – all high-status dwellings in some degree – for they are best documented. For more detailed information on the majority of the houses recorded here, readers are referred to the 3rd (revised) edition of *The Derbyshire Country House* (2 Vols, Landmark, 2001). Since the end of 2011, too, I have documented more fully a monthly lost house in that excellent Derbyshire publication *County Images*, a series which still continues, thanks to there being, still, no shortage of material. There is hardly space to devote to the parks, gardens, and art treasures affected by these losses, but the former are excellently covered in Dianne Barre's *Historic Gardens and Parks of Derbyshire* (Windgather, Oxford, 2017).

The following entries are by era, rather than cause of loss or date of building, and where the house was listed by what is now Historic England that is included in the heading (e.g. LG II, etc., for listed Grade II, and SAM for a scheduled ancient monument). If remains are listed they are included. To the right of the title I have indicated where public access is possible.

Maxwell Craven
Derby

The Lost Houses

1. Codnor Castle, Codnor, Alfreton, 1634

2. Melbourne Castle, Melbourne, 1637

3. Eastwood Hall, Ashover, Chesterfield, 1646

4. Broadgates Hall, Wirksworth, 1648

5. Mackworth Castle, Mackworth, Derby, 1655

6. Padley Manor, Padley, Castleton, 1676

7. Oldcotes, Heath, Chesterfield, 1711

8. Swarkestone Old Hall, Swarkestone, Derby, 1748

9. Markeaton (Old) Hall, Markeaton, Derby, 1755

10. Risley (Old) Hall, Wilne, Long Eaton/Nottingham, 1757

11. Foremark (Old) Hall, Repton, Burton-On-Trent/Derby, 1760

12. Kedleston (Old) Hall, Kedleston, Derby, 1760

13. Knowle Hill, Ticknall, Melbourne, 1761

14. Yeldersley (Old) Hall, Yeldersley, Ashbourne, 1784

15. Wingfield Manor, South Wingfield, Alfreton, 1774

16. Bretby Hall, Bretby, Burton-On-Trent, 1781

17. Hardwick Old Hall, Ault Hucknall, Chesterfield, 1789

18. Bearwardcote Hall, Etwall, Derby, 1791

19. Nether Hall, Darley Dale, Matlock, 1796

20. Hazelbarrow Hall, Eckington, Chesterfield/Sheffield, 1810

21. Eaton Dovedale, Doveridge, Ashbourne/Uttoxeter, 1811

22. Swanwick Hall, Swanwick, Alfreton, 1812

23. Foston Hall, Scropton, Ashbouyrne/Burton-On-Trent, 1832

24. Langley Hall, Kirk Langley, Derby, 1836

25. Castlefields, Derby, 1838

26. Ollersett Hall, New Mills, Chapel-En-Lefrith, 1840

27. Rowtor Hall, Birchover, Matlock, 1870

28. Thornbridge Hall, Ashford-In-The-Water, Bakewell, 1871

29. Bradshaw Hall, Eyam, Bakewell, 1883

30. The Grove, Darley Dale, Matlock, 1884

31. Coneygree Hall, North Wingfield, Chesterfield, 1890

32. New Hall, Castleton, 1890

33. Littleover Old Hall, Derby, 1891

34. Repton Park, Repton, Burton-On-Trent/Derby, 1893

35. Brailsford Hall, Brailsford, Ashbourne, 1901

36. Hasland House, Hasland, Chesterfield, 1919

37. Sutton Scarsdale, Sutton-Cum-Duckmanton, Chesterfield, 1921

38. Wirksworth Hall, Wirksworth, 1922

39. Brimington Hall, Brimington, Chesterfield, 1924

40. Farnah Hall, Duffield, Derby, 1925

41. Romeley House, Clowne, Chesterfield, 1925

42. Chaddesden Hall, Chaddesden, Derby, 1926

43. The Study, Bonsall, Matlock, 1927

44. Wingerworth Hall, Wingerworth, Chesterfield, 1928

45. Cliffe House, Newton Solney, Repton, Burton-On-Trent/Derby, 1930

46. Walton Old Hall, Walton-On-Trent, Burton-On-Trent, 1932

47. Aston Lodge, Aston-On-Trent, Derby

48. 1934 Allen Hill, Matlock, 1933

49. Darley House, Darley Abbey, Derby, 1934

50. Errwood Hall, Fernilee, Chapel-En-Le-Frith/Stockport, 1934

51. Drakelow Hall, Drakelow, Burton-On-Trent, 1934

52. Alvaston Hall, Alvaston, Derby, 1935

53. Doveridge Hall, Doveridge, Ashbourne/Uttoxeter, 1938

54. Tupton Hall, Tupton, Chesterfield, 1938

55. Heanor Hall, Heanor, 1938

56. Osmaston Hall, Osmaston-By-Derby, Derby, 1938

57. West Hallam Hall, West Hallam, Ilkeston, 1938

58. Bridge Hill House, Belper, 1939

59. Windle Hill, Thurvaston, Ashbourne, 1939

60. Derwent Hall, Derwent, Castleton/Sheffield, 1943

61. Trusley Manor, Trusley, Ashbourne, 1946

62. Shipley Hall, Mapperley, Ilkeston, 1948

63. Field House, Spondon, Derby, 1951

64. Wheston Hall, Tideswell, Bakewell, 1952

65. Snelston Hall, Snelston, Ashbourne, 1953

66. Spital House, Chesterfield, 1954

67. Etwall Hall, Etwall, Derby, 1955

68. Egginton Hall, Egginton, Derby/Burton-On-Trent, 1955

69. Ford House, Stretton-In-Shirland, Alfreton, 1956

70. Hopwell Hall, Ockbrook, Derby, 1957

71. Glapwell Hall, Bolsover, Chesterfield/Sheffield, 1957

72. Barrow Hall, Barow-On-Trent, Derby, 1957

73. Glossop Hall, Glossop/Stockport, 1958

74. Green Hall, Belper, 1958

75. Spondon Hall, Spondon, Derby, 1958

76. Ashbourne Hall, Ashbourne, 1958

77. Norbury Hall, Norbury, Ashbourne, 1960

78. Darley Hall, Darley Abbey, Derby, 1962

79. Aldercar Park, Heanor, 1962

80. Little Chester Manor, Little Chester, Derby, 1964

81. Markeaton Hall, Markeaton, Derby, 1964

82. Sutton Rock, Sutton-Cum-Duckmanton, Chesterfield, 1964

83. Denby Old Hall, Denby, Belper, 1966

84. Osmaston Manor, Osmaston-By-Ashbourne, Ashbourne, 1965

85. Parkfields Cedars, Derby, 1965

86. Alfreton Hall, Alfreton, 1968

87. Shallcross Hall, Whaley Bridge, Glossop/Stockport, 1968

88. Pilsley Old Hall, Clay Cross, Chesterfield, 1969

89. Breadsall Mount, Breadsall, Derby, 1970

90. Furness Lodge, Whalley Bridge, Glossop/Stockport, 1971

91. Stainsby House, Smalley, Heanor/Ilkeston, 1972

92. Oak Hurst, Alderwasley, Matlock, 1975

93. Potlock House, Findern, Derby, 1982

94. Stuffynwood Hall, Shirebrook, Bolsover/Mansfield, 1988

95. Burnaston House, Burnaston, Etwall, Derby, 1990

96. Mill Hill House, Derby, 2006

97. Thornhill, Derby, 2006

I

Before 1700

1. CODNOR CASTLE, 1634 (remains LGII/SAM)

Some public access

A motte-and-bailey castle of early eleventh-century date and therefore built by Robert, son of Warner de Codnor, alias de Morteine. Isolda, daughter of Robert's grandson Robert, brought it to Henry de Grey of Rotherfield by marriage about a century later, and the de Greys, later Lords Grey of Codnor (a title now revived for the Leighs), transformed it into a two-courtyard fortified manor house. Their successors, the Zouches, increasingly impecunious, migrated to America and in 1634 it was sold to Richard Neile, Archbishop of York, by whom it was largely dismantled, a much smaller residence being built within the ruins and still in use.

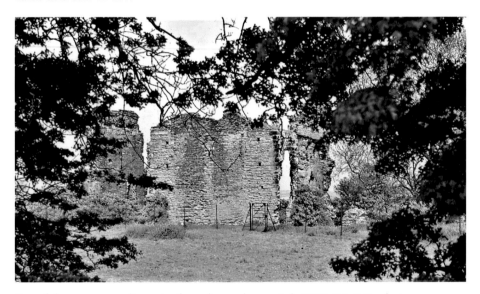

Part of the present standing ruins from the south-west, July 1974. (M. F. Stanley)

2. MELBOURNE CASTLE, 1637 (SAM, Castle Farm LGII)

Vestiges on private land

Melbourne Castle owed its existence to Robert de Holland – executed for treason in 1322 –who was granted a licence to crenellate his existing house

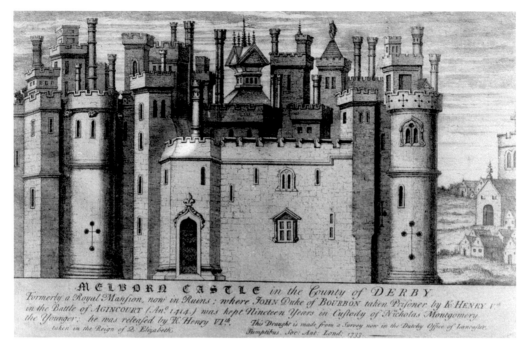

A 1733 engraving of the north side of the castle at Melbourne, copied from an original drawing now in the Duchy of Lancaster MSS PRO. (M. Craven)

there in 1311, whereupon master mason Peter de Bagworth built it in Keuper sandstone. In 1416, Jean, Duc de Bourbon, captured at the Battle of Agincourt, was interned here for nineteen years, with others. It was always a bit of a white elephant, however, and was 'dis-fortified' in 1461. After refurbishment as a possible prison for Mary, Queen of Scots in 1583, the park was sold to Sir Francis Needham in 1597 and the castle seven years later to Henry Hastings, 5th Earl of Huntingdon, whose son had demolished it and sold the materials by 1637. The present Castle Farm, Castle Square, contains some structural remains.

3. EASTWOOD HALL, ASHOVER, 1646 (LGII)

Private land; visible from road

Built by the Reresbys of Thrybergh, Yorkshire, as New Hall on their share of the huge manor of Ashover around 1450, probably on the site of a previous residence. After Prior Overton's Lodgings, Repton, it was Derbyshire's second lodge-type 'High House'. Sir Thomas Reresby impoverished himself rebuilding it, being forced to sell in 1623 to Revd Emmanuel Bourne, rector of Ashover, whose stubborn impartiality during the Civil War led to the partial destruction of the house in 1646, since which time it has mouldered quietly away, the substantial remains being a testimony to its stout construction.

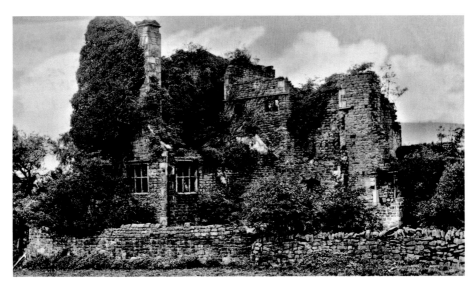

The ivy-covered shell of the house from a postcard dated 1916. (M. Craven)

4. BROADGATES HALL, 1648 (SAM)

Vestiges on private land

Remains excavated in 2007–09 of part of the seat of the Wingfield family, Roger de Winfield [*sic*] being granted lands there before 1320. Last resident, in much reduced circumstances thanks to the Civil War, was Richard Wingfield *c.* 1648. It was thereafter abandoned.

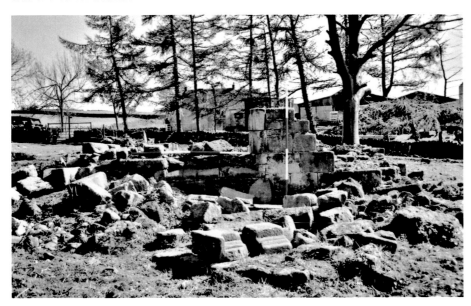

The vestiges of Broadgates Hall during excavation, looking south-east, April 2007. (M. Craven)

5. MACKWORTH CASTLE, 1655 (Gatehouse LGII*)

Private, visible from road

In the thirteenth century, the de Mackworth family, a younger branch of the Touchets of Markeaton, lived on that estate at Mackworth, from which place they took their name. Henry Mackworth began to rebuild his timber house, starting with a grand gatehouse, but inherited an estate in Rutland, and moving there, abandoned the task, which was never completed. Sold in 1655, it was demolished and a farmhouse built on the site of the house, leaving the shell of the gatehouse.

Mackworth Castle from the south-east, April 2018. (M. Craven)

6. PADLEY MANOR, 1676 (LGI & SAM)

Public access

Principal ancient seat of the notable Peak District family of Eyre, Padley Manor ended up as a two-courtyard house, which was inherited by the FitzHerberts. Two Catholic priests were seized there in 1589, being tried and beheaded at Derby, whilst Sir Thomas FitzHerbert died in custody. The Civil War killed off the fortunes of this branch of the family and, in 1676, the estate was sold to the Ashtons, from whom it descended to the Shuttleworths. The railway obliterated the outer court, but the northern one has been exposed by archaeology, whilst the surviving cross range was converted into a Catholic chapel in 1933.

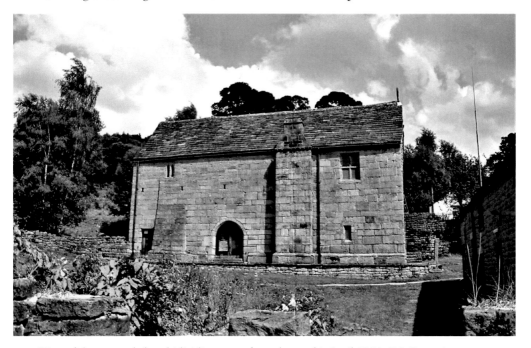

View of the restored chapel (dividing range from the south), April 2006. (M. Craven)

2

Losses 1700-1800

7. OLDCOTES, HEATH, 1711 (Vestiges LGII)

Private land

The last of Bess of Hardwick's 'prodigy houses', Oldcotes was of stone, with two towers, and thought to be the design of Robert Smythson, being built from 1593 on the site of a previous timber-framed house of the Hardwicks, who had inherited it from the Savage family. It was a smaller, simpler version of Hardwick Hall but was still larger than most Derbyshire houses. It was built for her son, William Cavendish, 1st Earl of Devonshire, and his somewhat extravagant son raised it by a storey between 1609 and 1626 when he inherited Chatsworth. The third earl sold it in 1641 to Robert

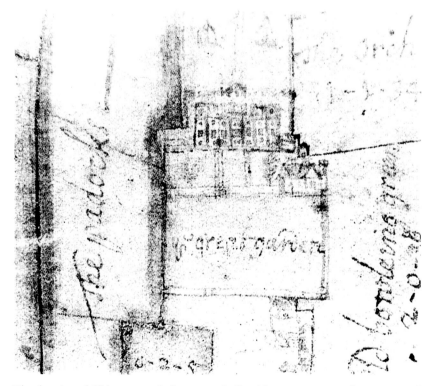

The drawing of Oldcotes, south front, as rebuilt with an extra storey from a map of 1659. (University of Nottingham, Manvers MSS)

Pierrepont, 1st Earl of Kingston, who later settled it on his youngest son, whose son, Samuel, altered it further in 1690. On his death in 1707 it devolved onto the 1st Duke of Kingston, who had it pulled down and a farmhouse built on the site around 1711.

8. SWARKESTONE OLD HALL, 1748 (stand LGI and remains LGII*)

Landmark Trust/private land
Swarkestone Manor was built on the Fynderne family estate by Chief Justice Sir Richard Harpur shortly after 1558, and seems to have been a house of

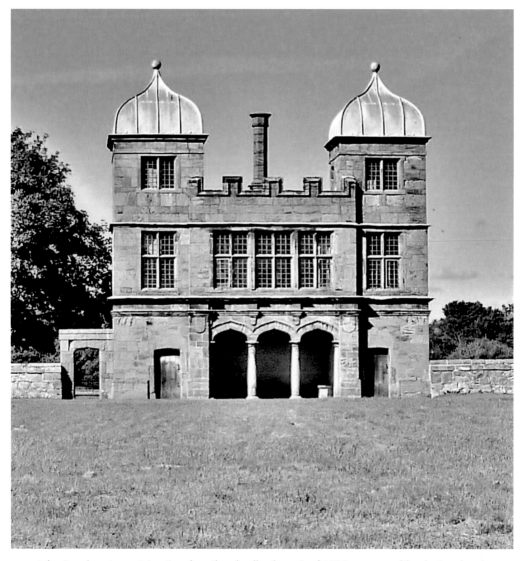

John Smythson's surviving Stand, or 'bowle alley house', of 1636 as restored by the Landmark Trust, August 2016. (M. Craven)

considerable size, built of Keuper sandstone. After the Civil War, during which it withstood a siege of five weeks, beginning in December 1642, the senior branch of the family failed in the male line and the estate devolved on to one of the junior branches of this prolific family, that of Calke. When the Countess of Bellomont, widow of the last Harpur there, died, it became redundant and was pulled down in 1746–48, leaving a number of walls standing, in places to some 20 feet high, some with fireplaces in them and one with a doorcase. The Stand, a superb banqueting house, by John Smythson and Richard Shepperd, 1632, survives by the remains of the bowling green and is now property of the Landmark Trust.

9. MARKEATON (OLD) HALL, DERBY, 1755 (vestiges LGII)

Vestiges in a public park

The Touchet family had Markeaton from Domesday until 1516, when they sold to the Mundy family, who built a grand new house not long afterwards. In was replaced in 1755 (see below) and the stables in 1772, although part of the original stable block survives on the north-west angle of the present stables and a pinnacle from the house marks the grave of F. N. C. Mundy's hunter in the pet cemetery.

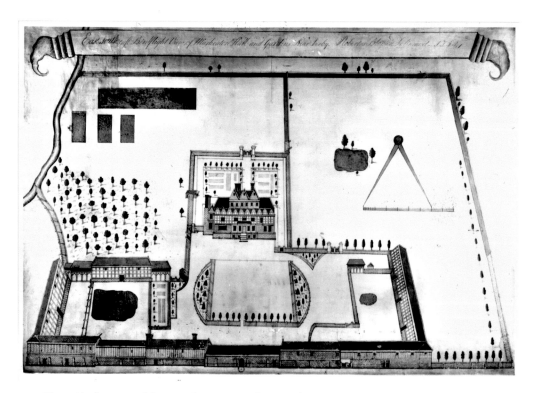

Plan with elevation of the 1516 house at Markeaton, showing the stables, of which much of the plinth still survives. (Derby Museums Trust)

10. RISLEY (OLD) HALL, 1757 (Terrace LGII*)

Hotel grounds

Risley Hall was an impressive early Tudor mansion built for Thomas Willoughby shortly after 1513, the year his father, Hugh, died. It was set in spectacular gardens. The family's last heiress, Elizabeth, died in 1723, after which the house became redundant. An attempt to sell it failed in 1743, and it was demolished in 1757. Vestiges of the Tudor gardens and their embellishments remain. The successor house remains, converted into an hotel.

A surviving sixteenth-century garden building in the grounds of the present hall, March 2021. (M. Craven)

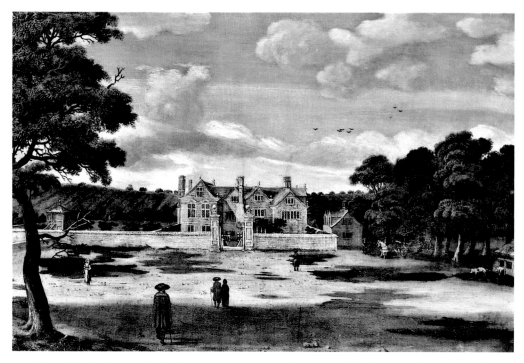

The old hall at Foremark, looking approximately south, from an oil painting attributed to Jacob Esselens of *c.* 1665, painting sold in 1998. (Christies)

11. FOREMARK (OLD) HALL, 1760 (Church LGI, stables LGII)

School: private/chapel, publicly accessible

The Burdetts came to Foremark in 1602 as a result of marriage with heiress Jane Franceys, to find the old house 'nigh ruinous'. It was fairly soon afterwards replaced in its entirety, being described in 1713 as 'large and convenient'. Sir Robert Burdett, 4th Baronet (1716–97), entirely replaced it in 1759–61. Only the chapel (now the church of St Saviour), also of *c.* 1662, with Robert Bakewell gates and altar rail, and the early eighteenth-century stable block survive from it.

12. KEDLESTON (OLD) HALL, 1760

National Trust

The fortunes of the Curzon family, who had been at Kedleston almost since Domesday Book, saw a significant improvement in the post-Restoration period, encouraging Sir Nathaniel Curzon, 2nd Baronet, to rebuild his large and ancient house there. Francis Smith of Warwick and his brother William were brought in and designed a fine brick mansion of nine bays of which the central three broke forward over a loggia, all with projecting corner pavilions.

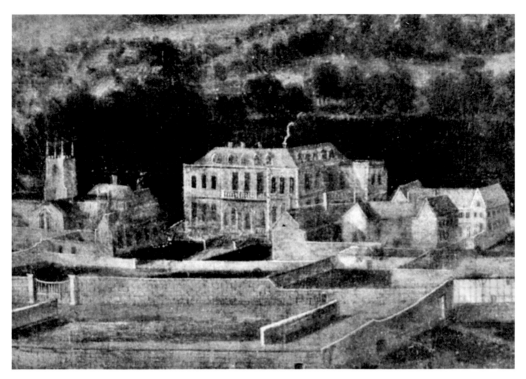

Painting showing the Smith of Warwick house from the north-east. (The late Viscount Scarsdale)

The probable date was around 1700, as suggested by the mullion-and-transom cross windows, although there were alterations made in 1727–34 for the 3rd Baronet. Nevertheless, it was not considered grand enough for the 5th Baronet, who decided to replace it with the present house, and it was entirely demolished by 1761, the year in which Sir Nathaniel was raised to the peerage as Lord Scarsdale, taking a title relevant to the location of his coal mining interests. A few of Smith's better marble chimneypieces were, however, transferred to the top floor of the new house.

13. KNOWLE HILL, TICKNALL, 1761

Landmark Trust

Built by the Franceys family, it passed to the Burdetts of Foremark, one of whom replaced the ancient seat with 'an extraordinary mode of structure ... a curious house', which passed eventually to the Hardinges of King's Newton, by whom it was embellished and set in a dramatic romantic landscape. Sold back to the Burdetts for use whilst Foremark was being rebuilt, it was surplus to requirements and demolished in 1761, being replaced by an equally romantic folly, now preserved as a holiday let.

A view north-east across the site looking towards the Trent Valley and Swarkestone Bridge, showing the ruins of the later folly, from a slide of July 1991. (M. Craven)

14. YELDERSLEY (OLD) HALL, 1784 (LGII)

Private; visible from road

Sometime in the sixteenth century, Christopher Pegge acquired an estate at Yeldersley from the Vernons, and built a new house there on a fresh site. Thomas Pegge, his descendant, married Catherine, daughter of his neighbour Sir Gilbert Kniveton, Baronet, and their daughter achieved some slight notoriety by becoming a mistress of Charles II in exile, by whom she had two children, one being Charles FitzRoy, later 1st Earl of Plymouth (1657–80). A later Pegge rebuilt the house, adding a low brick range of five well-spaced bays parallel to the road. The family sold up later in the eighteenth century, when it was acquired by Edmund Evans, of a Derby banking family, who demolished all but the Georgian range *c.* 1784 and the parallel stable range, converting one end of the latter into a farmhouse. In 1801 Evans built a new Yeldersley Hall on a fresh site.

Surviving Georgian wing of Yeldersley Old Hall as seen from the road, July 1991. (M. Craven)

15. WINGFIELD MANOR, SOUTH WINGFIELD, 1774 (LGI/SAM)

English Heritage, open to public

This great house was built from scratch on a commanding site around two
courtyards and three deer parks by Ralph, 4th Lord Cromwell, in 1442–52

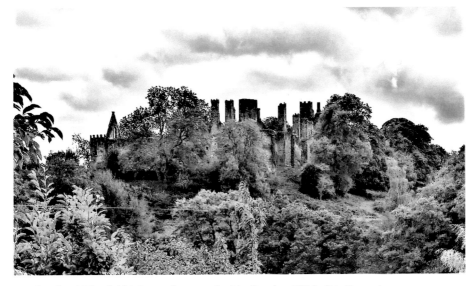

North side of Wingfield Manor photographed in October 2020. (M. Craven)

and incorporated a superb five-storey residential tower and a magnificent great hall. It later passed to the Earls of Shrewsbury, where the 6th Earl lodged his unwilling charge, Mary, Queen of Scots, from 1569. In 1616 the estate was triply divided and the house was held for the king in the Civil War until retaken by a siege in 1644, in which it was badly damaged. The Duke of Norfolk lodged his agent Immanuel Halton in the house from 1660, for whom the great hall was rebuilt as a two-storey house, whilst Halton, a pioneer of modern algebra, placed numerous sundials on the exterior. In 1773 Wingfield Halton completed a new, more convenient house nearby, and the old house was gutted and left to the elements, leaving only an extant farmhouse built out of the ruins.

16. BRETBY HALL, 1781 (LGII)

Private

Up until the 1690s, Bretby was the grandest house in Derbyshire by far. Previously there had been a fortified two-courtyard manor house at Bretby, crenellated by the Segraves and enlarged by the Marquess of Berkeley, but largely then demolished by Philip Stanhope, 1st Earl of Chesterfield, on his purchase of the estate in 1610. His opulent new house was on another site, very spectacular, and was a vast classical mansion reputedly the work of Inigo Jones, with a chapel added later by George Eaton of Etwall. The 2nd Earl extended the house in 1670 to

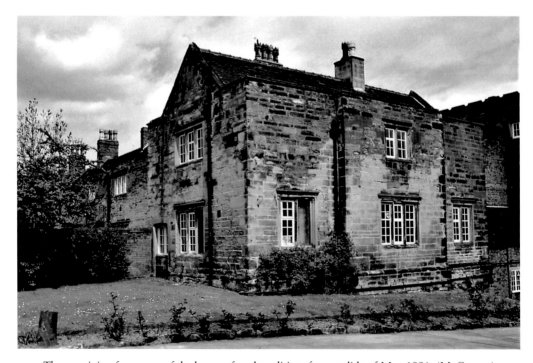

The remaining fragments of the house after demolition, from a slide of May 1991. (M. Craven)

designs by Louis le Vau and created extensive gardens, the work of René Grillet de Roven, a pupil of André le Notre. In 1777 his greedy agent advised the 5th Earl to demolish it entirely as a white elephant, a task which took until 1781, thereby considerably enriching himself. The Earl later bitterly regretted it, and a replacement house, Bretby Castle, was later built from 1812 partly on the site, and the wonderful gardens were turned into pasture. Some service accommodation survives, converted as dwellings.

17. HARDWICK OLD HALL, 1789 (LGI)

National Trust

The Hardwick family had resided atop the ridge overlooking the Doe Lea valley since the Middle Ages, having taken their name from the place. Their last representative was, of course, Bess, who became estranged from her fourth husband, George, 6th Earl of Shrewsbury, in the mid-1580s. Thereupon she began to rebuild the family's ancient seat in the grand Elizabethan High House manner, but without much of an overall plan, leading to a vast irregular pile with a mixture of flat topped balustraded towers and pointed gables. After the death of Shrewsbury in 1590, she finally gave it up and began all over again, this time using Robert Smythson, an accomplished architect, the result being the present Hardwick Hall. Thereafter her Cavendish descendants lived there until the completion of the present Chatsworth, after which it was used increasingly less.

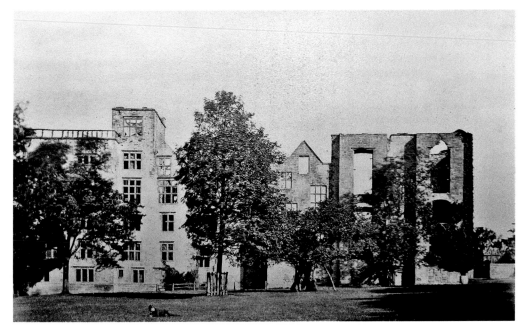

The south front in 1868, shortly before the removal of the roof over the Hill Great Chamber. The photographer, Richard Keene of Derby, lounges in the foreground whilst his colleague, J. A. Warwick, takes the picture. (M. Craven)

During this time the old hall was used as a sort of service wing and overflow guest accommodation, but by 1789 this had ceased and most of the house was unroofed and partly dismantled, although the west wing (containing the grandest rooms) was not unroofed until 1875. It was given to the National Trust by the 11th Duke of Devonshire in 1959.

18. BEARWARDCOTE HALL, 1791 (SAM)

Private land

For centuries this was the seat of the Bonington family, who, we are told, had a 'good house moted round with a bridge of stone and a gatehouse'. Longstanding financial difficulties forced the foreclosure of a mortgage in 1674 and the house and estate came into the hands of William Turner, their Derby attorney. His descendant, Exuperius Turner, sold it in 1764 to Robert Newton of Mickleover. He immediately set about replacing the old house with a modest villa in exuberant Strawberry Hill Gothic. The architect is known but could conceivably have been Sanderson Miller or even the young Joseph Pickford. Newton died in 1790, and his nephew John Leaper Newton inherited and, being already over-endowed with seats, immediately demolished the house, replacing it with the present farm. Only the stone bridge and the moat remain.

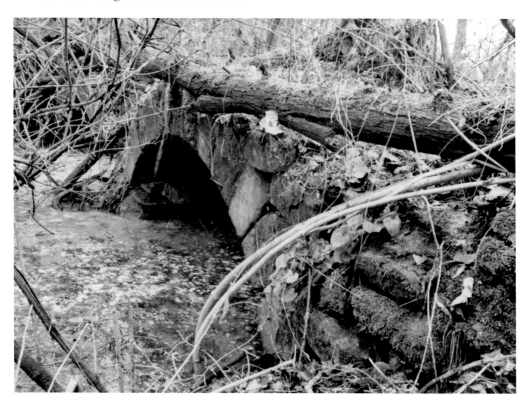

The surviving stone bridge over the moat, photographed by the late Don Farnsworth. (M. Craven)

19. NETHER HALL, DARLEY DALE, 1796

Private land

Darley was split into two moieties (portions) early on, with the death without male heirs of the last of the de Darley family, whose seat this was, a capital mansion being recorded on the site around 1321. Subsequently, it passed through the hands of numerous successor families. For many generations it belonged to the Foljambe family, under whom it was tenanted by a succession of entrepreneurs who were keen to exploit the lead-rich estate, notably the Columbells. Finally, it was acquired by Sir Richard Arkwright from the Wrays, and his son pulled it down in 1796, leaving a few vestiges, now long since lost. Originally built around a courtyard, one range survived. Latterly the subdivided great hall flanked two later gabled cross wings, probably seventeenth century.

Drawing copied by Llewellyn Jewitt from the Woolley MSS in the British Library, published in *The Reliquary*, showing the much-reduced house in the mid-eighteenth century. (M. Craven)

3
LOSSES 1800-50

20. HAZELBARROW HALL, ECKINGTON, 1810 (Gatepiers LGII)

Private land

An H-shaped gabled house built, probably about 1570, for William Selioke, whose family had held the estate since the early fourteenth century. He sold up in 1587 and, after some vicissitudes, it ultimately came to Anthony Morewood in 1635 at a cost of £2,450. In 1670, when tax was paid on eleven hearths, it changed hands again, ending up with the Wingfields, from whom it passed to Robert Newton (also of Bearwardcote qv), whose heirs let it and then, in 1810, demolished it. The site is now covered by planting near the surviving home farm (Grade II listed), which includes parts of the old house, including a magnificent pair of gate piers.

The house as built around 1670 from a painting done by the daughter of the vicar of Norton, *c.* 1800. (Private collection)

21. EATON DOVEDALE, DOVERIDGE, 1811

Private agricultural land

In 1576, William Milward bought an estate between Sedsall and Doveridge overlooking the Dove to the west and backed by trees on rising ground. It appears

Woodcut made retrospectively by Joseph Tilley of the house in its last years. (M. Craven)

to have been a stone twin gabled house of two storeys and attics, with multipaned mullioned and transom windows. In the early seventeenth century, an extra bay was added to the north in matching style. It ceased to be occupied by the mid-eighteenth century, and was said to have been ruinous by the end of that century. It seems to have been demolished in 1811, although vestiges remained for some decades after that and the cellars are said to survive beneath the present Hall Farm house.

22. SWANWICK HALL, 1812

Private, school grounds

In the Civil War the original hall estate at Swanwick was bought from the Royalist Brailsfords by coal owner John Turner. He rebuilt the old hall in 1675, but his grandson and heir built a new house, further away, in 1690, in classical style, four square, of Pentrich sandstone, with three storeys and a flat balustraded roof. His firm was taken over by Anthony Tissington, who moved in and was succeeded there by his like-named son, elected FRS in 1767 and an associate of John Whitehurst and Erasmus Darwin. He let the house in 1771 and sold much of the estate to a business partner, Hugh Wood. The house fell empty in 1791 and

Engraving from the south-west, done in the 1770s. (M. Craven)

was bought and demolished by Wood to extend his parkland in 1812. Nothing seems to remain of it.

23. FOSTON HALL, 1832 (part of later building, LGII)

Private, HM Prison

A seventeenth-century house of some size was built for Sir Charles Agard, whose family had been at Foston for centuries. However, the estate had been sold and its

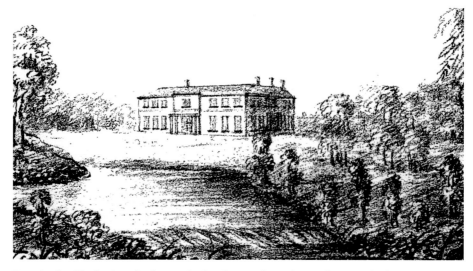

Drawing by Charles Sneyd Edgeworth, dated 1816, from the south-east. (The late Sir Howard Colvin)

new owner, an opulent *arriviste* called John Broadhurst, built a new brick house of two storeys in high Regency style and also relandscaped the surrounding parkland. The architect might have been George Basevi; the resemblance to Bromesberrow is striking. Regrettably, any records were probably lost in the fire that completely destroyed the house in 1836, when it was in the tenancy of Col Charles Thorold Wood. The site remained empty for twenty-seven years before Broadhurst's son commissioned the present house from T. C. Hine of Nottingham, incorporating service range and other fragments of its predecessor.

24. LANGLEY HALL, MEYNELL LANGLEY, 1836

Private

In 1108, Robert de Meynell held land at Langley, and the family twice ended in heiresses and the second time had to buy it back. Although the village – essentially all of current Kirk Langley east of the Ashbourne Road – vanished in the Black Death, the ancient house endured, much rebuilt. It lay around a single courtyard, and was essentially fourteenth century with later additions and alterations. In 1757, the family again ended in heiresses, and although they eventually managed to repurchase most of the estate south of Flagshaw Lane, the northern part passed to the Peach family, who in 1836 demolished what remained of the old hall (much having been removed in a modernisation in 1758) and built the present Langley Hall in its place.

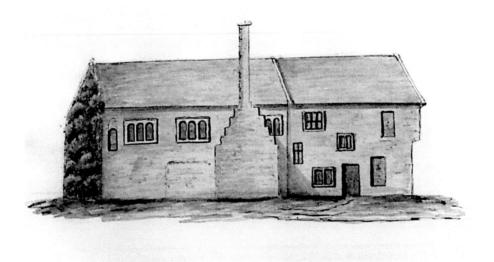

Langley old Hall as it appeard when part taken down 1834.

Painting by Godfrey Meynell (1779–1854) of the medieval north-west range, 1834. (Godfrey Meynell)

25. CASTLEFIELDS, DERBY, 1838

Suburban streets

Absolutely no trace remains of the fine Queen Anne seat of the Borough family, being built in *c.* 1713 when William Woolley was writing his history of Derby. Alderman Isaac Borrow (*sic*), for whom it was built (its architect is not known), went on to become Mayor of Derby in 1730 and 1742, His son and heir was painted by Joseph Wright. At the time of a 1730 painting, now in the museum, the gardens were very formal, their limits being defined today by Borough's Walk

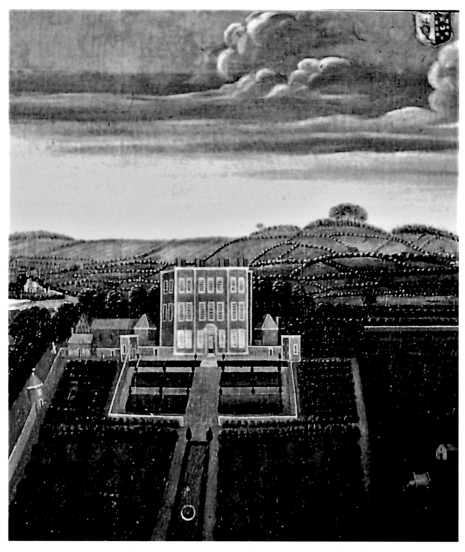

Anonymous panoramic oil painting of *c.* 1730 showing house and gardens from the west. (Derby Museums Trust)

(now Traffic Street), London Road, Canal Street and Siddall's Lane (now Siddall's Road). By the later 1790s, it had been relandscaped, possibly by William Emes, in a pastured landscape. Yet shortly afterwards the family acquired Chetwynd Park, Shropshire, and retired there, letting Castlefields, which was eventually sold to John Copeland and demolished for redevelopment.

26. OLLERSETT HALL, NEW MILLS, 1840

Private agricultural land
The Bradburys had held land at Ollersetts since 1318 and in 1598, Sir Thomas Bradbury of Ollersett was Lord Mayor of London. The house would appear to have been built by Nicholas Bradbury in 1569 (the only possible interpretation of the recut date stone now on the adjacent farm house) and in 1670 tax was paid on seven hearths, suggesting a modest size, despite the existence of an enigmatic drawing with its domed tower and battlements. It passed eventually to absentee landlords and was inhabited by the agent up until about 1840, after which it appears to have been dismantled, the staircase being saved but where it went is unclear.

The present Ollersett Hall, a farm on part of the site, which has the original date stone built in but recut. Photographed in 1981. (M. F. Stanley)

4

Losses 1850-1900

27. ROWTOR HALL, BIRCHOVER, 1870

Private

In 1564, Aden Beresford of Fenny Bentley sold Stephen Eyre of Hassop a portion of his estate at Birchover, an element in the constant interplay between Derbyshire landed families of the Peak striving to gain an advantage in finding lead and thus a potential fortune. He proceeded to build a house 'suitable for a gentleman to inhabit', probably in the 1560s. A younger son, Roger Eyre, settled there and made alterations in the 1630s. Thomas Eyre, in Queen Anne's reign, built a domestic chapel and created a fantasy landscape from Rowtor Rocks adjacent to his house, including caves, grottoes, steps, a throne and an obelisk, all of which survive. The house was let from 1757 and was abandoned in the nineteenth century, the shell being cleared in 1870 to build a new parsonage for the adjacent chapel.

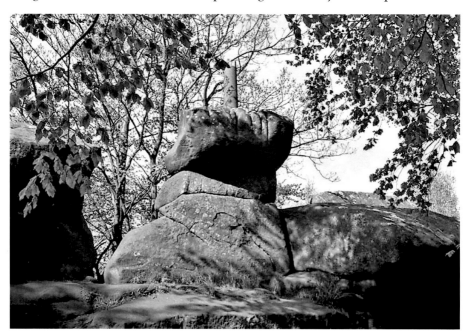

Rowtor Rocks, the obelisk (somewhat truncated), March 2021. (C. Craven)

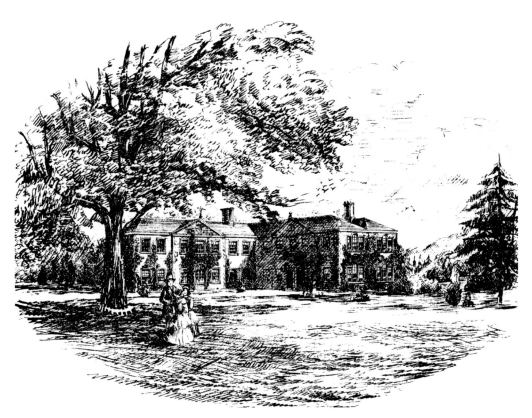

South front of the Georgian house, from the 1871 sale catalogue. The original house is on the right, the addition on the left. (M. Craven)

28. THORNBRIDGE HALL, ASHFORD-IN-THE-WATER, 1871

Private

Thornbridge was long part of the estate of the Longsdons of Little Longstone, one of whom, James, had become a successful merchant in Manchester. He had built a modest house of two storeys, seven bays under a pediment, in a stunning location with superimposed Venetian windows on the east front. In 1790 he sold it to his business partner, Andrew Morewood, although he retained much of the modest estate. Morewood added a new range at right angles but in matching style (perhaps using the same architect, possibly a Manchester man). It passed to the McConnels of Cressbrook, who sold it back to the Longsdons, from whom John Sleigh of Leek, Staffordshire, bought it. In 1871, he sold it to another Mancunian businessman, Frederick Craven, who promptly demolished it and used the materials to build a new Jacobethan house.

29. BRADSHAW HALL, EYAM, 1883 (remains LGII)

Private

In 1565 Francis Bradshaw came into lands at Bretton and Foolow (*sic*), as well as much of Eyam 'including ye auncient manor house' by virtue of his marriage to one of the five co-heiresses of Humphrey Stafford of Eyam. In 1635, George Bradshaw inherited it and the lead-rich estate from an elder brother and set about rebuilding the house. Yet it was still a work in progress when George died in exile in 1646, having been a supporter of the king in the Civil War. Worse, the son and heir died in 1659 before he could reclaim his patrimony at the Restoration. Yet the family did return only to leave again when the 1665 plague broke out, never to return. It was let, then subdivided, then run as a small cotton mill and thereafter merely abandoned having been bought by the Wrights of Eyam Hall in 1883.

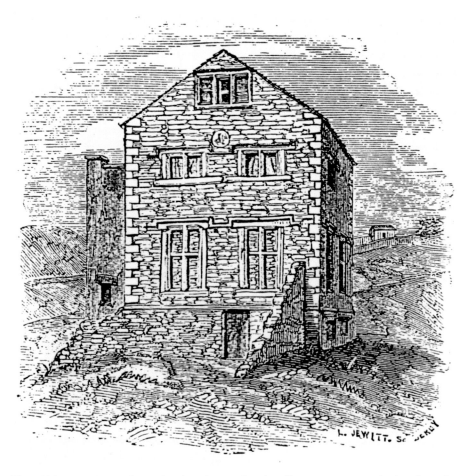

The 1635 cross-wing as drawn for the reliquary by Llewellyn Jewitt, 1874, which collapsed in 1962. (M. Craven)

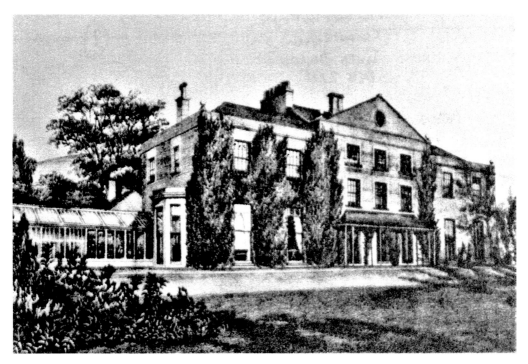

View of the house from the north-west, from the sales particulars, 1876. (James Darwin, Esq.)

30. THE GROVE, DARLEY DALE, 1884

Private

The Grove stood on the site of the former St. Elphin's School (now retirement homes), which was in 1904 re-established in a rather splendid former hydro, which had started out in 1885 as the extravagantly Gothic home of Manchester merchant William Roberts. To build this striking edifice, now flats, Roberts bought and heedlessly demolished a Regency classical house of seven bays and two storeys. It originated as the home of lead merchant John Alsop of Lea Wood in 1820, but his grandson (also John) added lower wings and a central pediment *c.* 1835 before migrating to Canada in 1842. It was let to Revd W. H. Bathurst and later to Robert Pringle, before sale to the opulent Mr Roberts in 1876.

31. CONEYGREE HALL, NORTH WINGFIELD, 1890

Private, industrial site

Francis Brailsford, a member of an ancient knightly family long settled in North Wingfield, built a new house in around 1762. The architect was probably Edmund Stanley of Chesterfield, who clearly liked to bend the rules of Palladian architecture: superimposed Venetian windows, with a lancet of Gothic glazing

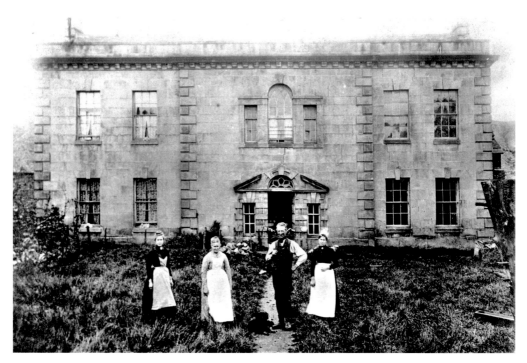

The south front of Coney Green Hall, taken in 1883 with the Clay Cross bailiff, wife and two servants standing in front. Note the unkempt garden. (Cliff Williams)

bars in the top ones, and not only a superfluity of Gibbs surrounds below, but an open pediment applied in a particularly eclectic manner. In 1772 it was sold to Thomas Fanshawe of Fanshawegate but soon afterwards it passed to the Wilsons. In 1873, George Banks Wilson sold it and the small park to the Clay Cross Company, who installed their bailiff and tipped iron slag onto the parkland. Undermined by subsidence, it was demolished in advance of further coal mining in 1890.

32. NEW HALL, CASTLETON (SAM), 1890

Private

Alice, one of the five daughters and co-heiresses of Humphrey Stafford of Eyam (see Bradshaw Hall, above), married John Savage of New Hall, Castleton, whose family had been long settled there. The eldest son, Humphrey, rebuilt the house, providing a large cross wing with fine ceilings in *c*. 1570. The family were ruined and dispersed for having supported the king in the Civil War, and the estate seems to have come to the Morewoods of The Oaks and Staden, but before 1800 Micah Hall, a rich Castleton attorney, had acquired it, replaced the central (great hall range) and split it as labourers' cottages. In 1889 the Halls sold to the local Wesleyan Methodists, who demolished it and whose chapel, built in 1890, overlays part of the site.

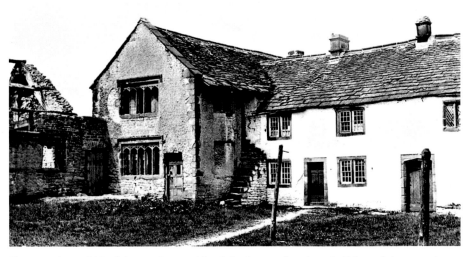

Photograph *c*. 1880 of the north-east side of the house after the rebuilding of the central part and its conversion into cottages. (Private collection)

33. LITTLEOVER OLD HALL, 1891

Private

Around 1580 Sir Richard Harpur built a miniature prodigy house in the Hardwick mode on the site of the old manor house of the Fyndernes. Sporting square tower-like pavilions at the angles, in 1754 it passed by marriage to Derby Tory grandee

Littleover Old Hall, south front, as rebuilt, drawn by Godfrey Meynell (1779–1854) around 1820. (Godfrey Meynell)

Samuel Harpur, whose posterity built a new seat further west at The Pastures, and let the hall as a farm. Through the nineteenth century it was progressively reduced and the estate was sold in 1890, the hall going to Edward MacInnes, who demolished and replaced the house with the present Arts and Crafts edifice. A chimneypiece, a column (as a sundial) and some walls survive.

34. REPTON PARK (remains LGII), 1893

Private land

A sumptuously romantic house demolished as a result of a row between Sir Vauncey Harpur-Crewe, 10th Baronet, and his cousin, John Edmund, who lived there, as a result of which the nephew had to leave and the house was wantonly demolished. Begun *c*. 1632 for Sir Henry Harpur, of Calke Abbey, 1st Baronet. as a hunting lodge, probably to a design by John Smythson (cf. Swarkestone Old Hall, above), it was rebuilt with an extra storey and angle towers by Samuel Brown of Derby for Sir George Crewe, 8th Baronet, in 1811 in grounds breathtakingly landscaped with a large lake possibly a generation before by William Emes. Remains of the Jacobean gatehouse survive and other elements were used to add a sturdy portico to a neighbouring property.

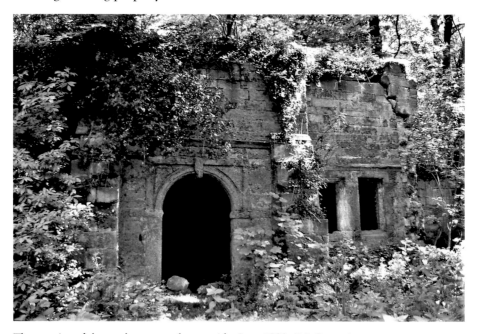

The remains of the gatehouse, south-west side, June 1990. (M. Craven)

5
LOSSES 1900-40

35. BRAILSFORD HALL, 1901

Private
The Shirley family inherited a moated house here from the Brailsfords, but it had long vanished when lead trader William Cox bought the estate from 5th Earl Ferrers. In 1813 Derby amateur Richard Leaper remodelled and enlarged Cox's farmhouse as a Regency stuccoed villa for his son Edward Soresby Cox. Here, surrounded by a small park, the family lived until 1900 when William Cox died and the estate was sold to multimillionaire George Herbert Strutt, who, contemptuous of so modest a house, demolished it and replaced it with a much larger affair in neo-Jacobean style.

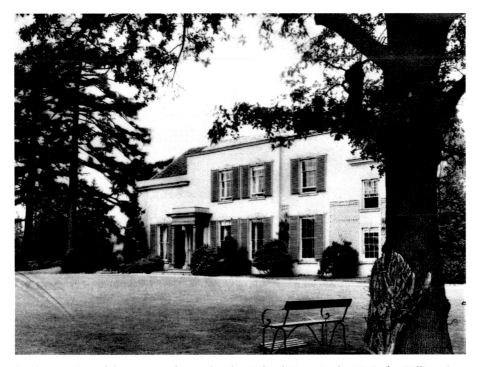

South-west view of the entrance front taken by Richard Keene in the 1860s for William Cox. The former farmhouse is the part on the right. (George Cash)

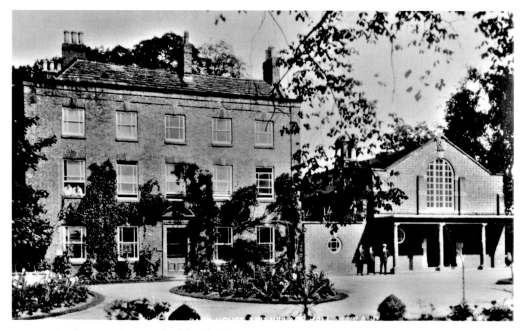

Hasland House photographed beside the new village hall, from a postcard dated 1914. Five people got included in the shot, but who were they? (M. Craven)

36. HASLAND HOUSE, 1919

Public Park

The break-up of the ancient manorial estate at Hasland after the Civil War saw a parcel of it ultimately coming to the Lucas family, rich Chesterfield merchants. In 1729 Thomas Lucas built a brick villa surrounded by a small park as a coming-of-age present for his second son, Bernard (1708–71), probably to a design by George Sims of Chesterfield. In 1818 a grandson of Bernard sold it in 1818 to Josiah Claughton, a Chesterfield druggist, who later replaced the windows with plate glass sashes. In 1912, the Claughtons sold it to Chesterfield Council for incorporation into Eastwood Park but, after the First World War, no use could be found for the house and it was demolished in 1919, leaving part of the ground floor beside the 1914 village hall that was built alongside it.

37. SUTTON SCARSDALE (remains LGI), 1921

English Heritage

The Leake family had long held Sutton Scarsdale, but in 1724–27 Nicholas Leake, 4th Earl of Scarsdale had Francis Smith of Warwick build him one of the most splendid houses in Derbyshire, incorporating parts of its late Elizabethan predecessor. On his death in 1736, the estate had to be sold to pay

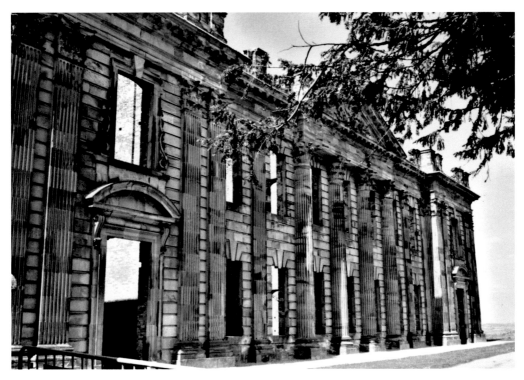

The same, as a stabilised ruin, photographed as a slide in June 2001. (M. Craven)

his debts and descended via the Clarkes to the Marquess of Ormonde, who sold to the Arkwrights. They sold it, the setting blighted by coal extraction, in 1921 and a contractor gutted it and removed the roof. Several rooms were shipped to Philadelphia Museum in the USA. Sir Osbert Sitwell saved it from complete demolition at the eleventh hour in 1950 and gave it to the nation in 1969. The ruins are magnificent, but the site is blighted by the proximity of the M1.

38. WIRKSWORTH HALL, 1922

Private

The hall was preceded by a seventeenth-century house called The Hill, occupied by Francis Hurt, whose nephew embellished it with the *c.* 1731 Robert Bakewell gates and screen from Casterne Hall in 1767. The new house, called Wirksworth Hall, was built in 1780, the architect being Joseph Pickford of Derby. Charles Hurt FRS, a notable astronomer and a friend of Herschel, later added a library for his 35,000 books. The house was sold to Nicholas Price Wood with 400 lead-rich acres in the 1840s, and in the 1890s the Woods let the house and moved the gates to their Shropshire home, Henley Hall. Subsidence and lack of tenants led to sale in 1919 and demolition in 1922. A forlorn gate pier and part of the stables survive.

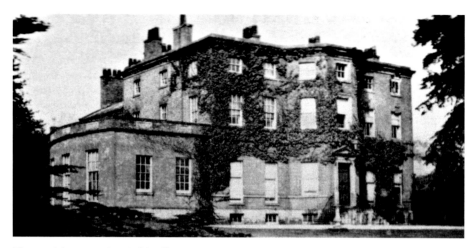

The surviving gate pier, Coldwell Street, June 2018. (M. Craven)

39. BRIMINGTON HALL, 1924

Private

The estate came to the Foljambe family of nearby Walton in the 1440s and the house was built or rebuilt by George Foljambe *c.* 1554. In 1633 it was sold to Col Gill, from whom it passed (with added accretions) to the Heywoods and

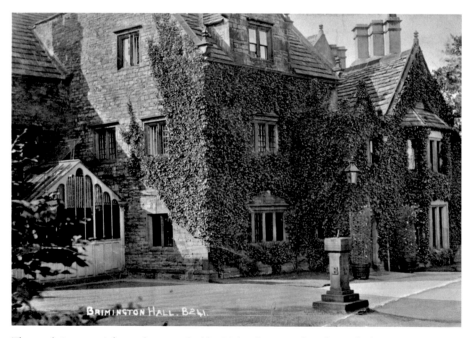

The south (entrance) front photographed by Richard Keene of Derby in the later 1870s. (David Coke-Steel, Esq.)

then the Cokes. In the 1830s the latter let it to Bernard Lucas and later Charles Paxton Markham was born there, but in the end R. G. Coke sold it to the Staveley Company for their manager to inhabit, but it was none other than the unsentimental C. P. Markham, as chairman, who had it demolished in 1924, the outbuildings following in 1931. The site was built over.

40. FARNAH HALL, DUFFIELD, 1925

Private

Farnah Hall was built in 1736 for John Coape, probably by William Smith of Warwick. The son, William Coape, added a stable block and icehouse in the 1770s and landscaped the park, probably designed by William Emes, who provided his usual lake. Sold in 1799 to 2nd Lord Scarsdale and part of the Kedleston estate ever since. His son Nathaniel had it enlarged in 1820, probably by Richard Leaper, but after he succeeded to the estate in 1837, the house was let until it fell vacant in 1916. In 1925 a survey found it structurally unsound and it was unroofed, gradually falling into decay, a process hastened in the Second World War by Home Guard use.

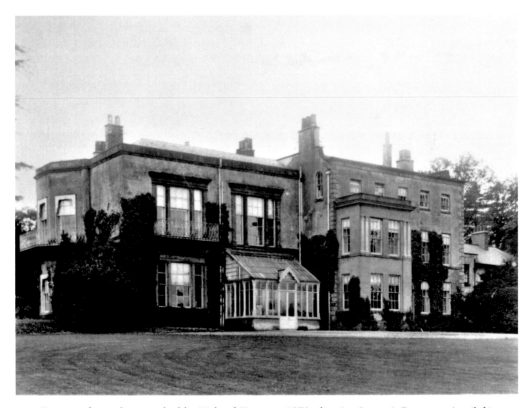

Entrance front photographed by Richard Keene, *c.* 1870, showing Leaper's Regency wing (left) and square bay. (Late Viscount Scarsdale)

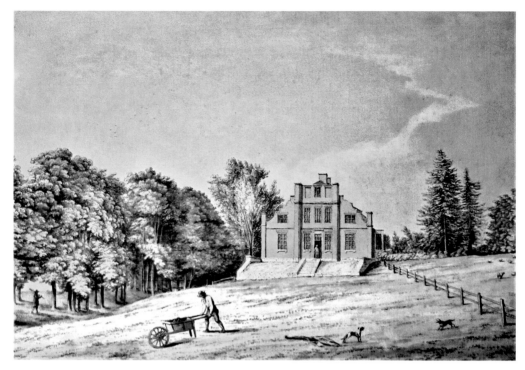

Romeley House, as depicted in 1774 by Samuel Hieronymus Grimm. (Private collection)

41. ROMELEY HOUSE (Hall ruins, LGII), 1925

Private

A delightfully eccentric house of the south Yorkshire school built 1711 for
Thomas Wright, who bought the estate from the Routhe family, whose house
was nearby, but which later became a farm. It was sold in 1788 to Daniel Hill,
who let it for life to Dr. Thomas Gisborne PRCP, who called in William Lindley
of Doncaster to rebuild it in Palladian style and Revd. Christopher Alderson,
Queen Charlotte's gardener, to landscape the grounds. It passed, mainly let,
from the Hills to the Oliviers, who had abandoned it by the beginning of the
twentieth century and it was sold, ruinous, with the farmland in 1921 and was
cleared in 1925. The impressive remains of its predecessor still grace the nearby
farmyard.

42. CHADDESDEN HALL, 1926

Public park

In 1610 Derby clothier Robert Wilmot acquired part of the fragmented
Chaddesden estate near Derby and, in 1611, built a modest house. His

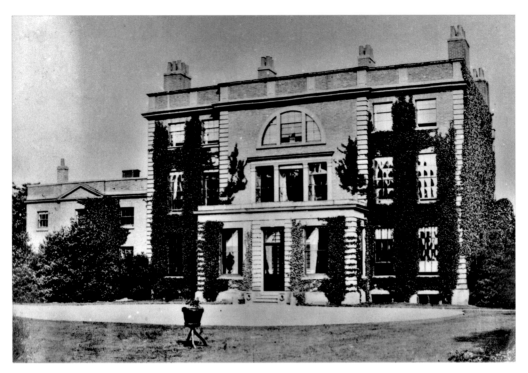

Photograph of the entrance front as rebuilt in 1818, taken by Richard Keene in 1858, some years before the addition of the ballroom on the right. (M. Craven)

descendant, Sir Robert Wilmot, 1st Baronet, having married an heiress, replaced it, probably to the designs of Francis Smith of Warwick. His grandson rebuilt it in 1818, enlarging the central portion by installing a huge lunette over a tripartite window and extending it on the garden front too. In 1873 Col Sir Henry Wilmot, 5th Baronet, VC, KCB, MP, added a ballroom to the north side and on his successor's death in action in the First World War, his widow left and the house, long empty, was sold in 1926 and demolished, much of the estate being built upon.

43. THE STUDY, BONSALL, 1927

Private farmhouse
A charmingly eccentric Gothic house created for Adam Simpson and his wife Mary, daughter of Sir Richard Arkwright, probably by Arkwright's tame architect, George Rawlinson of Matlock Bath, 1781. It passed by descent from their son to Henry Flint and from him to the Prince family, the third of whom made modest additions in 1872. The family died out in 1927, and the house mysteriously 'went on fire' that year and was destroyed. A surviving bay from the 1872 additions was incorporated into the present farmhouse. Stables survive as holiday lets.

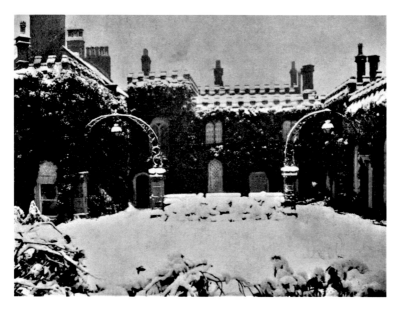

A view of the
entrance front
after a heavy
snowfall,
c. 1905, from
a postcard.
(Bonsall
Local History
Society)

44. WINGERWORTH HALL (surviving ranges LGII), 1928

Private

Built to replace a particularly interesting Jacobean house attributable to John Smythson in 1728 by Francis Smith of Warwick in his grand manner for Sir Thomas Windsor Hunloke 3rd Baronet, whose family had acquired the

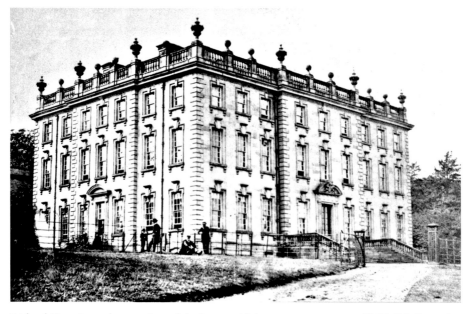

Richard Keene's south-west view of the house with house party guests, *c.* 1867. (M. Craven)

coal-rich estate from the Curzons in 1582. The view from the house was of mines and foundries, so William Baker of Audlem, William Emes and finally Humphrey Repton all massaged the 85-acre park to obviate the nuisance. The family sold up in 1920 and William Twigg & Co. demolished it in 1928, some of the interiors being sold in 1929 by Robersons of Knightbridge. Two service ranges survive along with the stables, lodge and gate piers. The park has been largely built over.

45. CLIFFE HOUSE, NEWTON SOLNEY, 1930

Private

In the nineteenth century Newton Solney was well stocked with the villas of Burton Brewers, to which Cliffe House was added in 1859–60, built for Samuel Ratcliff, of Messrs Bass, Ratcliff & Gretton, by Robert Grace of Burton-on-Trent on land acquired from the Earl of Chesterfield in 1858. It was built in a hurry for a dying owner and was reputedly cold and draughty, being sandwiched between the road and River Trent. The last Ratcliff left during the First World War and it was let to Bass head brewer Percy Kent LeMay, who left in 1929, after which, finding no takers, it was sold and demolished in 1930. Stables survive as a house.

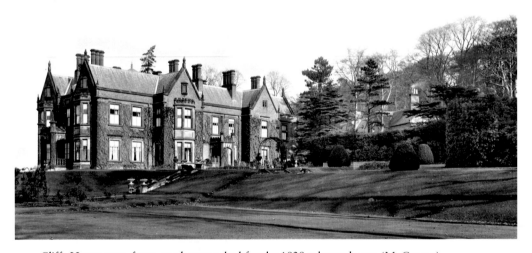

Cliffe House, west front, as photographed for the 1929 sale catalogue. (M. Craven)

46. WALTON OLD HALL, WALTON-ON-TRENT, 1932

Private

The descendants of the last de Ferrers Earls of Derby acquired the estate in 1349, but a house was not built until the mid-sixteenth century. It was built in timber, but extended in brick in the 1660s when there were seventeen hearths. It went out

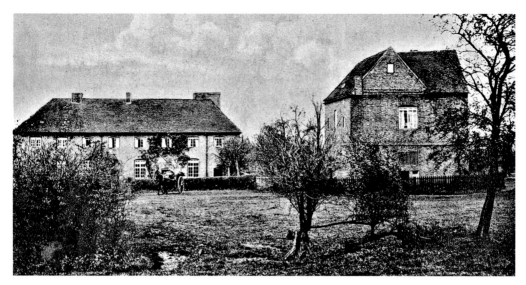

The remains in 1907, seen from the south, including stable range, with remnant of hall to right. From a postcard. (M. Craven)

of Ferrers ownership in the early eighteenth century, passing, tenanted, through a succession of great families with no need of it themselves, until sold in 1855, much reduced. It was mostly cleared away in 1935, leaving the stable range (now a single house) and a single-storey brick fragment acting as a garage.

47. ASTON LODGE, ASTON-ON-TRENT (Gates LGII), 1933

Private housing
Aston Lodge was built *c.* 1738, possibly to the designs of Francis and William Smith of Warwick, for Joseph Greaves, enriched by lead trading. His son's widow

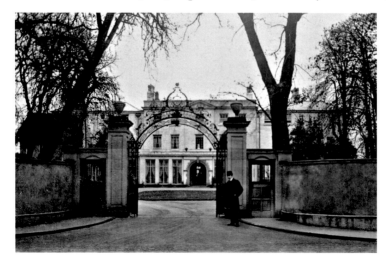

Aston Lodge viewed through Reginald Boden's splendid Bakewell Gates, from a postcard dated 1919. (M. Craven)

sold it in 1791 with 68 acres for £4,500. In 1815 it was sold again, shorn of the estate, to George Hulbert, who gave it a Regency makeover, possibly with the help of Derby's Richard Leaper, then working nearby on Aston Hall. It was sold by his widow in 1827 to the Suttons of Shardlow, who let it throughout the nineteenth century, until it was sold again in 1908 to Reginald Boden, who built new stables and acquired a pair of wrought-iron gates by Robert Bakewell from a house in Derby to which he added his crest and monogram. In the mid-1920s it was briefly a nursing home before being bought by Alfred Loomes in 1927 and demolished for housing in 1933. The water tower and stables were converted for housing, and the gates went to West Park, Long Eaton.

48. ALLEN HILL, MATLOCK, 1934

Private

Allen Hill was typical of dozens of small stone-built houses of minor gentlemen in Derbyshire. The Woolleys of Riber Hall purchased the estate from the Wendesleys in the 1570s and Anthony Woolley began building in 1624. Son Adam Woolley

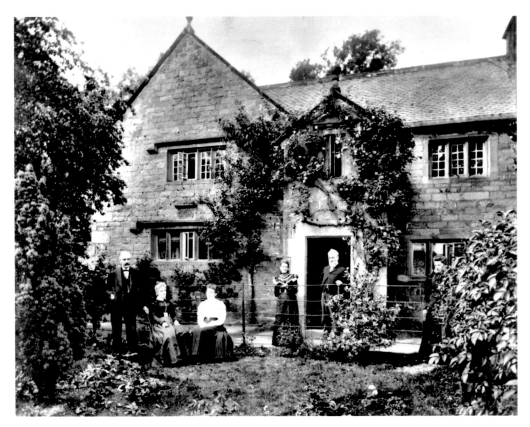

Allen Hill's south (entrance) front with tenant farmer Edward Slack and his family arrayed in front, *c.* 1890. (Derbyshire Museum Service)

extended the house in 1674, and the last of the family, Adam Woolley FSA, died in 1827 at a great age. It had been let as a farmhouse in 1807 and so continued under the ownership of the Woolley-Dods of Edge Hall, Cheshire, until 1934, when it was sold and demolished by the use of dynamite to make way for a new hydro, which, in the event, was never built, thanks to the war. It is now a housing estate.

49. DARLEY HOUSE, DARLEY ABBEY, 1934

Private

The Evans family established a cotton mill at Darley Abbey in 1782, and in 1785 the son and heir, William Evans, married Jedediah Strutt's daughter Elizabeth and a villa called Darley Fields was designed for them by William's brother-in-law William Strutt FRS, finished in 1791. Widowed in 1796, Elizabeth remarried Walter Evans, her brother-in-law, in 1798 and the house was doubled in size. Various Evanses lived there after Elizabeth's death in 1839, but it was let to Col James Cavendish in 1908 and became a prep school in 1918–30, when it closed and the house was sold, being demolished in 1931 for its materials and the site built over.

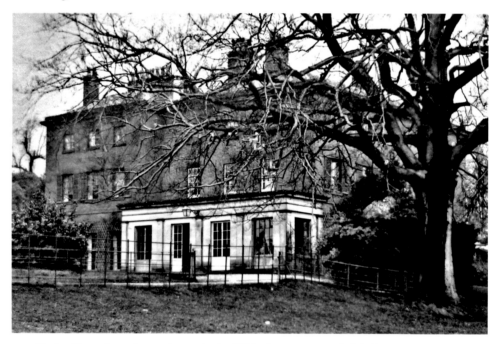

Darley House from the south-east in the 1920s, from a postcard. (M. Craven)

50. ERRWOOD HALL, FERNILEE (LGII), 1934

Public country park

Roman Catholic Manchester businessman Samuel Grimshaw bought 2,064 acres of moorland in 1841 and proceeded to build an Italianate villa, designed

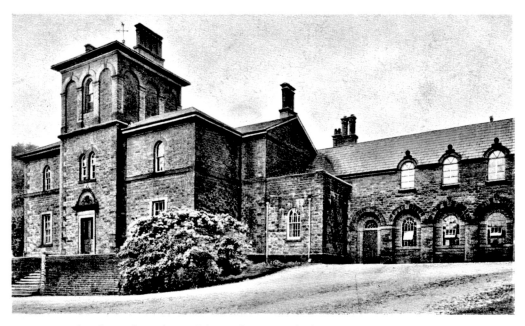

Errwood Hall, east front, from a lithographic postcard of 1905. (M. Craven)

by Alexander Roos. Plans for a large Gothic chapel designed by Sir Alexander Beresford Hope, were, however, unrealised due to Grimshaw's death in 1851, and Hope merely extended the house to accommodate something more modest. Romantic grounds were laid out probably by Edward Milner. The family died out in 1930 and Stockport Corporation bought the estate, let the house to the YHA and started work on flooding the Goyt Valley (by 1936 in Derbyshire) as a reservoir. The house was dismantled for materials in 1935 and left as a ruin, recently reduced for 'health and safety' reasons. A shrine and other parkland structures survive.

51. DRAKELOW HALL (gates and terraces LGII), 1934

Private
Drakelow Hall was the seat of the Gresleys from the twelfth century until 1931. The most recent house was built in 1525, classicised twice in the eighteenth century, given a Regency makeover in 1806–20 by John Westmacott and Samuel Brown, further altered by Robert Grace of Burton-on-Trent and then heavily rebuilt by Sir Reginald Blomfield in 1901–04 for Sir Robert Gresley, 11th Baronet. Crushing financial pressure led to the family leaving in 1931 and leasing the house and grounds as a country club and motor racing circuit, an enterprise which failed in 1934 when Sir Clifford Gothard bought the estate, demolishing the house. Much of the site was compulsorily purchased in 1950 for a pair of power stations, and the rest was sold in 1991. Magnificent gate piers and a lodge remain on Walton Road; a terraced garden by the river also survives.

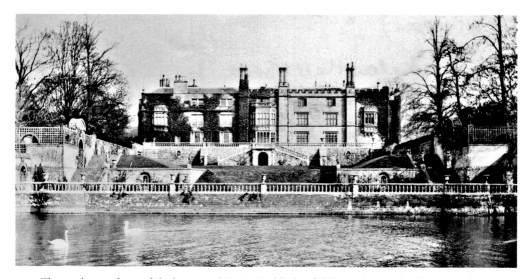

The north-west front of the house and Sir Reginald Blomfield's newly completed terraces, from a postcard by Frank Scarratt. (M. Craven)

The surviving gate piers and a glimpse of the power station, from a slide taken in May 1991. (M. Craven)

Alvaston Hall as it was in the late nineteenth century, from a watercolour. (Derby Local Studies Library)

52. ALVASTON HALL, DERBY, 1935

Private

The Allestrey family were descended from a villein of Darley Abbey, freed and settled at Alvaston. A descendant, William Allestrey MP, acquired the estate in the wake of the Dissolution and his descendant, another William Allestrey MP, was Recorder of Derby until unseated in the Civil War for Royalism and is thought to have built the house. The family lost the estate in a legal dispute to John Tempest Borrow in 1741 and it ended up being purchased by Joseph Wheeldon in 1817, who got John Price to rebuild the house. Sold to Herbert Dagley in 1850, it descended to the Smiths, who let it and, in 1935, sold it. It was demolished to build houses.

53. DOVERIDGE HALL, 1938

Private

Bess of Hardwick's eldest son, Henry Cavendish, was given Doveridge with 1,704 acres by his mother and in 1769–77 a very grand new house was built for Sir Henry Cavendish PC (I) to a design of Edward Stevens, who died in 1774, leaving

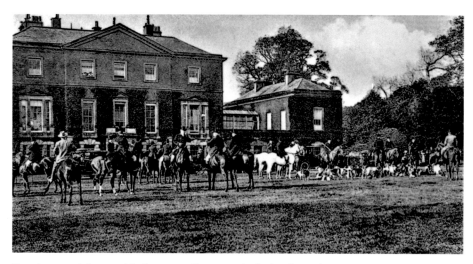

East (entrance) front, with the Meynell Hunt (of which 4th Lord Waterpark had been master) gathering before the off, *c.* 1900, from a 1907 postcard. (M. Craven)

it to be finished by Joseph Pickford of Derby, who delegated his assistants Thomas Gardner and Thomas Freeman to add pavilions. Sir Henry's descendant, 4th Lord Waterpark, sold the estate around 1901 to Frank Brace, who resold to 1st Lord Hindlip, who let it. In 1935, with no tenant in sight, he sold it, and in 1938 the house was demolished by a building contractor.

54. TUPTON HALL, 1938

School
A unique and fascinating miniature Hardwick attributable to John Smythson, son of Robert, its builder, who erected Tupton Hall in 1611 for Henry

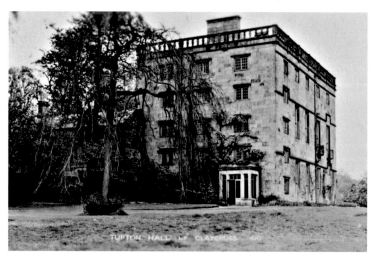

Tupton Hall from the south-west after the First World War, from a postcard sent in 1923. Note the furthest bay of five storeys: typically Smythson-esque. (M. Craven)

Gladwin, who incorporated his initials into the parapet. An intriguing mixture of levels inside were simplified in a rebuilding of *c.* 1771 by William Allwood Lord, to whom it had descended. Sold in the 1790s to the Packman family, they let it, latterly selling to the county council for a school in 1929. This opened in 1936 but in July 1938 the old house burned down and the remains were cleared.

55. HEANOR HALL, 1938

School, now derelict

A fine brick and stone house of three full storeys and enlivened by shaped end gables, built not long before 1670 by Samuel Roper. He was a coal owner, as were all his successors. His nephew John, Cofferer to Queen Anne, let it to the Goodheres and the Fletchers before selling to John Sutton in 1792, from whom it eventually passed to John Ray, whose family sold it to the Miller Mundys of Shipley (qv) in 1881. They in turn sold to the School Board in 1893 for conversion to Heanor Grammar School but it was sacrificed to expansion in 1938, its notably fine successor school building being designed by G. H. Widdows.

Colour lithographic postcard view of the hall in its guise as Heanor Grammar School, taken from the south-east, *c.* 1904. (M. Craven)

56. OSMASTON HALL, OSMASTON-BY-DERBY, 1938

Industrial estate

In 1637 Robert Wilmot, of the Chaddesden Hall family (qv), acquired the estate here, and in 1696 his house was replaced by a much grander affair attributable to Sir William Wilson. In 1750 Robert Bakewell made his final pair of stylish gates for the park and, at about the time, the family were raised to a baronetcy and William Emes landscaped the park. In 1814 the house with 32 acres was let to Samuel Fox of Derby, but his posterity was driven out by the din of the nearby iron foundries, and the house was sold to the Midland Railway as offices, although the tracks of a headshunt were laid almost to the door. In 1937 the LMSR sold to Derby Council, who demolished it in 1938 in anticipation of building a housing estate, not started due to the war. After 1945 the area was developed as an industrial estate instead.

Wilson's noble south front in extreme decay, autumn 1937, the LMS having stopped using it four years before. (Derby Evening Telegraph)

South front and terrace of the hall at around the time of the First World War when it was lived in by Spencer H. Rook. (Malcolm Burrows)

57. WEST HALLAM HALL, 1938

Private

Originally the site of a large medieval house of the Catholic Powtrells and Hunlokes, who demolished it in 1777, it was not until 1876 that a new house was built to designs by John Parkin of Derby for the agent of the Newdigate family of Arbury. Sold to Henry FitzHerbert Wright and then in 1913 to Nottingham alderman Sir Albert Ball, tenants included Spencer Rook and the last was industrialist Sir Charles Markham, 1st Baronet, no less. It was demolished in 1938 to make way for housing.

58. BRIDGE HILL HOUSE, BELPER (Lodge and icehouse LGII), 1939

Private

By 1793, with the Strutt family's mills dominating the town, George Benson Strutt was having a house built on Bridge Hill on the west side of the Derwent. It was a substantial classical villa designed by George's elder brother William. An extension was added around 1800 and it was succeeded to by three further generations of Strutts until the death of the philanthropic George Herbert Strutt in 1928. His widow died in 1931, but thereafter there was a dearth of Strutts willing to live

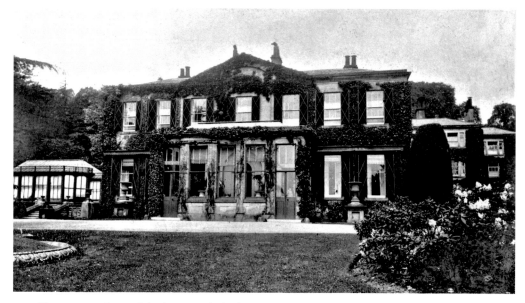

The entrance front of the house with the later extension to the right, photographed in around 1890. (M. Craven)

over the shop, nor any potential tenants. It lay empty until 1938 when it was sold and demolished for housing in 1939, leaving three pretty stone-built lodges, on Bridge Hill, Lodge Drive (with the icehouse nearby) and Belper Lane.

59. WINDLE HILL, THURVASTON, 1939

Private

Originally a fairly large house, built in the 1660s in timber by Robert Rowe on the site of a previous, early Tudor house of the Mynors family, it was inherited

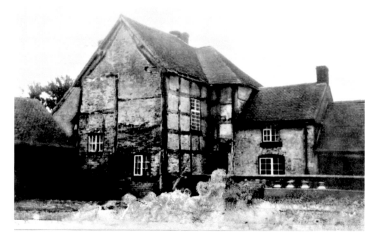

A north-west view of the remaining portion of the house as it was *c.* 1909, from a postcard.

by the Newalls and in the mid-eighteenth century they extended the house in brick. Their heirs, the Portes of Ilam, Staffordshire, let it as a farmhouse, reducing it accordingly. The Fox family lived there until it became redundant and derelict by the 1930s, and was cleared away in 1939, replaced by a new house alongside.

6

Losses 1940–59

60. DERWENT HALL, 1943

Reservoir

Derwent Hall in 1876 was a very modest stone gabled house dating from 1672, built for Henry Balguy, a lead trader, and lightly modernised by his son in 1692. The family sold up in 1767 to the Bennets, who were followed by the Reads and in 1846 by the Newdigates of West Hallam (qv) and Arbury. In 1876 it was bought by the Duke of Norfolk to bestow on his younger son Lord Edmund FitzAlan-Howard, who appointed J. A. Hanson to enlarge the house considerably, in matching style, and add a chapel. Lord Edmund was appointed the last Viceroy of Ireland in 1921 and was in consequence created 1st Viscount FitzAlan of Derwent. Not long afterwards it was sold *force majeur* to the water authority for the building of a reservoir; the family left in 1932 and, after a decade as a youth hostel, it was finally vacated, stripped, dismantled and drowned in 1943 by the Derwent Reservoir. Elements rescued from it survive in the mayors' parlours of Derby, Nottingham and Sheffield, co-sponsors of the destruction.

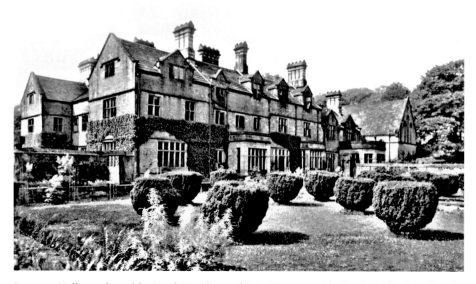

Derwent Hall as enlarged by Lord FitzAlan and J. A. Hanson, with the Catholic chapel at the right, from a postcard postmarked 1908. (M. Craven)

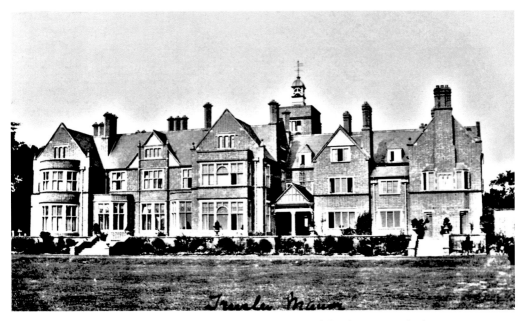

The newly completed house from the south from a postcard dated 1906. (Derbyshire Museums Service)

61. TRUSLEY MANOR, 1946

Private
Trusley has been in the hands of the Coke family since the fourteenth century, although it passed out of the family to an absentee branch of the Wilmots between 1718 and 1818, by which time the original manor house had virtually disappeared. The Cokes moved back at the end of the nineteenth century from their seat in Nottinghamshire, and in 1902 Major General J. T. Coke built a very substantial neo-Jacobean house to the designs of George Eaton of Derby and F. Bowles of London. The family had hardly moved in when war intervened, two sons becoming casualties in the second conflict, a tragedy which persuaded the heirs Mr and Mrs Ronald Coke-Steel to demolished about three quarters of the house in 1946. The remaining portion was subdivided and let until 2022, when it was refurbished to house a member of the family.

62. SHIPLEY HALL (estate buildings LGII & II*), 1948

Public country park
The Jacobean house at Shipley, three stories with attics, was built by the Leche family, but inherited by the Mundys, who pulled it down in the 1740s, replacing it with a new house in 1749, itself completely rebuilt by William Lindley of

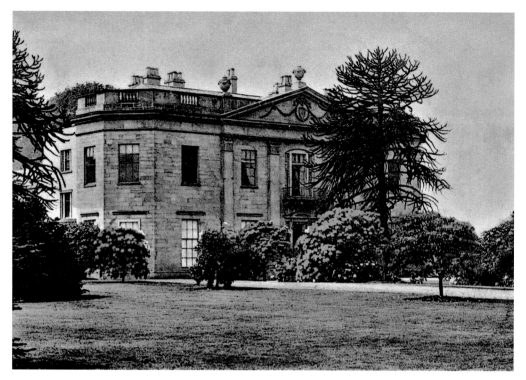

Shipley prior to rebuilding, from the south-west, a tinted photograph of *c.* 1890, from a postcard. (M. Craven)

Doncaster in 1799–1800 (landscape by Emes, 1779) and greatly enlarged and embellished by Sir Walter Tapper in 1895–98. Death duties led to the sale of the house and estate to the family-owned colliery company, and the house remained empty until nationalisation when the NCB mined beneath it and were obliged to demolish in 1948. Splendid estate buildings by W. E. Nesfield in the 1860s survive in the country park. House footprint indicated in the grass with stone blocks.

63. FIELD HOUSE, SPONDON (Gate piers LGII*), 1951

School (gates: public road)

Essentially a good quality Regency villa, built on the site of a previous house in 1818 by Bryan Balguy, then recently appointed town clerk of Derby, and set in a small park of 13 acres. The architect weas possibly Samuel Brown of Derby, and the inspiration was perhaps the west front of Egginton Hall of 1780 (qv). Fine stone gate piers by Gibbs were added by 1938 when St. Mary's Gate House, Derby, was pulled down, which survive, unlike the house, which passed to the Devas family and was demolished in 1951 to make way for a new secondary school.

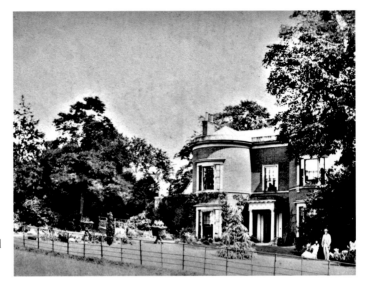

The west front as photographed by Richard Keene in around 1859. (Private collection)

64. WHESTON HALL, TIDESWELL (LGII), 1952

Private

In 1727 a late sixteenth-century house of the Alleynes was rebuilt and refronted in impressive style for Thomas Freeman, who laid out a park and

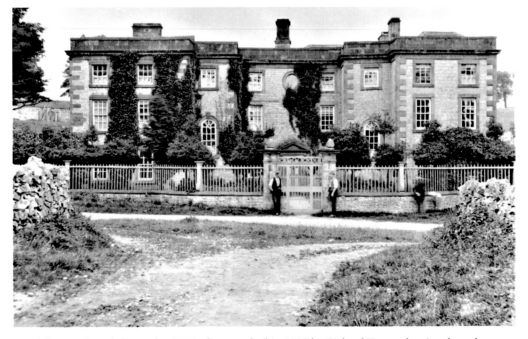

The grand north front of *c.* 1727, photographed in 1858 by Richard Keene, showing the rather splendid (lost) gate piers and timber screen. (M. Craven)

an avenue. It later passed to the Chatsworth estate and became a farmhouse, but structural neglect resulted in the unexpected collapse of much of the north front in a gale in 1952. The remains were adapted as a new, much smaller, house in 1960.

65. SNELSTON HALL (gates and ruins LGII), 1953

Private

John Harrison was a Derby attorney who suddenly became very wealthy and commissioned a series of designs for a villa at Littleover and a seat at Snelston from Lewis Cottingham, whose fourth design, an accomplished Gothic fantasy that admirably complemented Alton Towers nearby, won favour and was built in 1827–32. The interior was breathtaking, with fine furnishings and carving by Adam Bede of Norbury (*sic*). It passed to the Stanton family in 1906, who were forced by death duties to demolish it in 1953 and adapt the stable block as its replacement. Some portions remain along with estate buildings, also by Cottingham.

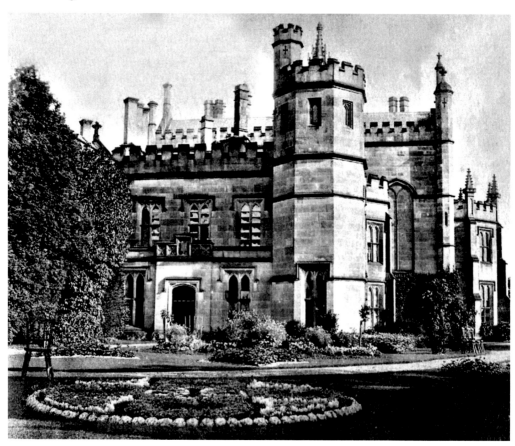

The west front, photographed in the early 1890s. (Private collection)

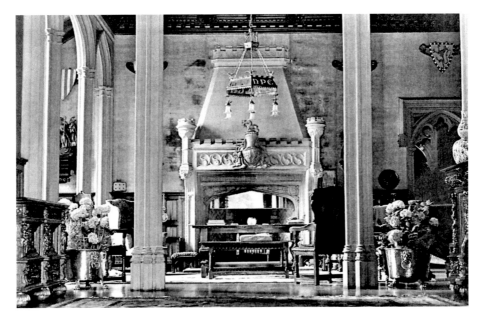

The great hall, *c.* 1900. (Private collection)

66. SPITAL HOUSE, CHESTERFIELD (barn LGII), 1954

Private
Spital House was built in 1570 by Gervase Shaw on the former land of Chesterfield's Lazar hospital, and was rebuilt by Richard Jenkinson after 1617.

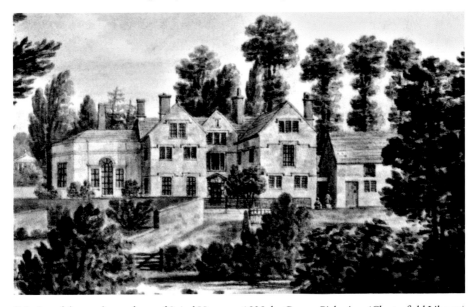

Painting of the south-east front of Spital House, *c.* 1828, by George Pickering. (Chesterfield Library)

It was later sold to the Woodyears, after whom it passed to the Bournes, who added an awkward looking eighteenth-century wing, and Chesterfield alderman John Charge, who had married the Bourne heiress, but was let most of the time. It lay empty throughout the Second World War and was demolished *c.* 1954, leaving its impressive barn, now converted as a residence.

67. ETWALL HALL (gates & piers LGII*), 1955

School

The Porte family acquired the estate at the Dissolution of Repton Priory, and the Gerards and Mosleys succeeded them before, in the Civil War, Roundhead Sir Samuel Sleigh acquired it, plundering stone from Tutbury Castle to build a new house, with two towers flanking the south front. His successors, the Cheethams, had Francis Smith of Warwick rebuild it in classical style in 1713–26. Robert Bakewell supplied a superb iron screen with gates. The Cotton family inherited it but died out in the 1950s, when the empty house

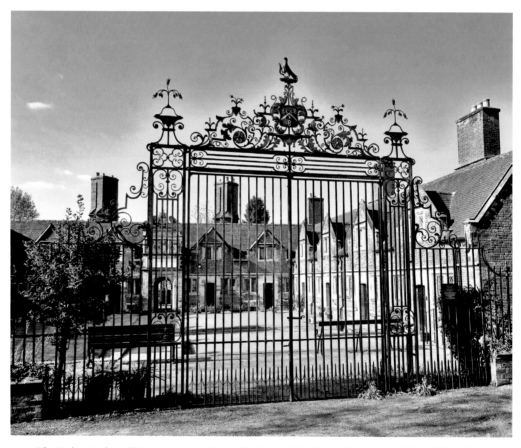

The Robert Bakewell Gates, as repositioned in front of the Porte Almshouses (Etwall Hospital), April 2021. (M. Craven)

was purchased by the county council to build a school in 1955. The gates and screen, restored, were repositioned in front of the Porte almshouses adjacent and may be visited.

68. EGGINTON HALL (bridge LGII*), 1955

Private

In the adjoining parish of Egginton, the hall there, an impressive neoclassical mansion of 1780 by Samuel Wyatt, was sold by Sir John Every, Baronet, and demolished in the same year. Set in a William Emes park of great beauty, the house was the seat of the Everys from the early seventeenth century when they had inherited from the Lathburys via the Leighs. The previous house had burnt down in 1736. A new house by Adam Bench in similar style was erected on the site in 1997 for Mr. K. Ellis, but an extremely early cast-iron footbridge over the neck of the lake by Coalbrookdale, 1812, survives in different ownership and seriously at risk.

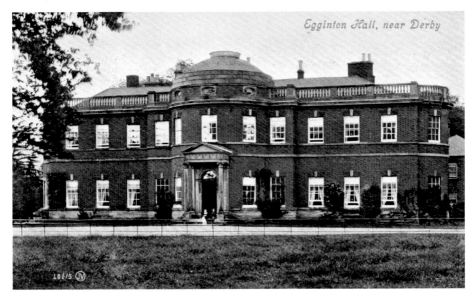

Egginton Hall, near Derby

Colour printed postcard view of the south front of Egginton Hall, postmarked 1907. (M. Craven)

69. FORD HOUSE, STRETTON-IN-SHIRLAND (LGIII), 1956

Reservoir

A perfectly sound, handsome villa of around 1780, possibly by Thomas Sykes of Chesterfield, was compulsorily purchased by the Water Board from the Turbutts of Ogston and demolished a year later in 1956 to be replaced by a line of four 'reservoir houses' well above the water line of the new reservoir, which drowned one of the prettiest valleys in the county. The house was built by Enlightenment connoisseur John Holland, whose family had purchased its predecessor in 1680 and whose widow's heirs sold to the Turbutts.

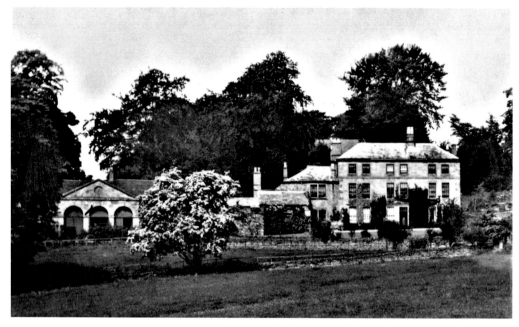

Postcard view from the south of the house and stables. It would require the use of a boat to repeat this view today! (M. Craven)

70. HOPWELL HALL (LGII), 1957

Private
A tall three-storey brick house with giant pilasters at the angles built by Henry Keyes in 1720, on an estate acquired from the Sacheverels in Tudor times. It

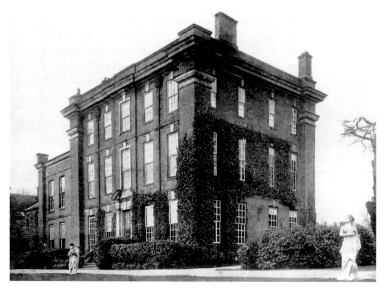

A view of the tall house in muscular baroque, from the south-east, later nineteenth century. (Late Lt Col T. H. Pares)

was sold to Sir Bibye Lake, 1st Baronet, in 1734 and the Pares family, Leicester aldermen, bought it from the 3rd Baronet in 1786. They sold up in 1921 and the house was converted into a special school by Nottinghamshire Council. Unfortunately, it burned down in 1957, being replaced by a purpose-built structure, since tactfully converted to single residential use.

71. GLAPWELL HALL (LGII), 1957

Private

A substantial seventeenth-century gabled house built for the Hallowes family, who had inherited the estate from the Woolhouses. It was extended in Queen Anne's reign, which included rebuilding the domestic chapel, and in the 1870s a substantial wing was added to the south-east angle by Giles and Brookhouse of Derby. by Giles and Brookhouse of Derby. Before the First World War it was let to the Gorell-Barnes family and afterwards to the Mather Jacksons, who eventually sold up in 1952 and, the new owner finding no tenants, was demolished in 1957. A pair of gate piers survive.

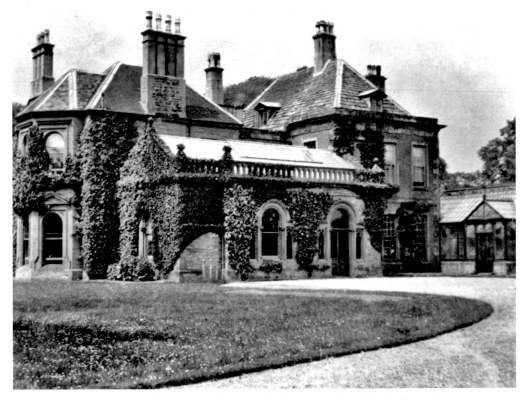

The south-east corner of the house showing the Victorian wing with the Queen Anne range behind, from a postcard. (M. Craven)

72. BARROW HALL, BARROW-ON-TRENT (LGII), 1957

Private

Barrow Hall was a Regency seat of the Beaumonts, rebuilt around elements of their Tudor house by Derby amateur architect Alderman Richard Leaper in 1809.

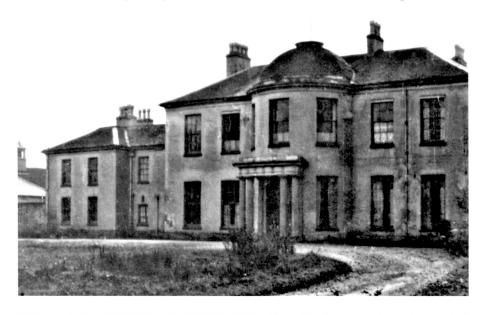

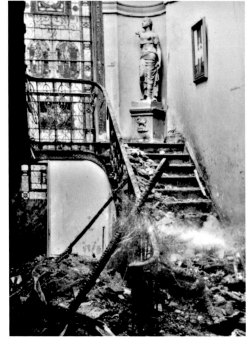

Above: North entrance front, photographed on a gloomy day in 1955. (M. Craven)

Left: The staircase seen after the fire, 13 September 1956. (M. Craven)

The Beaumonts sold in 1876 to Col J. T. Pountain, a Derby vintner, who died in 1889 when it was sold again, to James Eadie, a Burton-on-Trent brewer. It was a home for refugees in the Second World War, but was later sold for conversion into flats, but was destroyed by fire in September 1956, the remains being cleared for house building a year later. Two very pretty lodges survive.

73. GLOSSOP HALL (LGIII, surviving lodge LGII), 1958

Public park

The Earls of Shrewsbury had a hunting lodge at Glossop until 1616 when it came to the Dukes of Norfolk, becoming the seat of a younger branch of the family, who built a substantial house in the mid-seventeenth century. This was entirely rebuilt in 1815 by Robert Abraham, and further altered for 1st Lord Howard of Glossop in 1850 by Matthew Ellison Hadfield, producing an enormous, rambling house, further embellished by John Douglas of Chester in 1903, set in stunning grounds which survive as a public park. Purchased by Glossop council in 1926 as a school, it closed in 1953 and was demolished in 1958–59, bungalows being built on the site. One lodge of 1852 survives along with the gardens, making a fine public park.

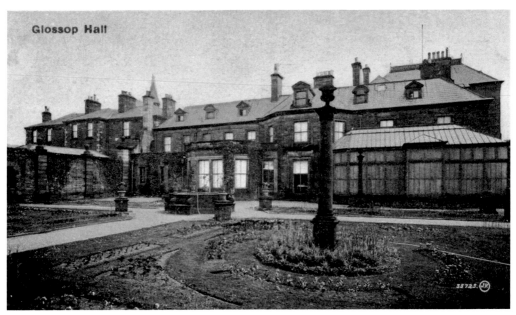

A coloured lithographic postcard view of the west side of the house, dated 1917. (M. Craven)

74. GREEN HALL, BELPER (LGIII), 1958

Public car park

The Strutts became all-pervasive in Belper from the 1770s and Jedediah Strutt's eldest son, William, was something of an amateur architect, having designed

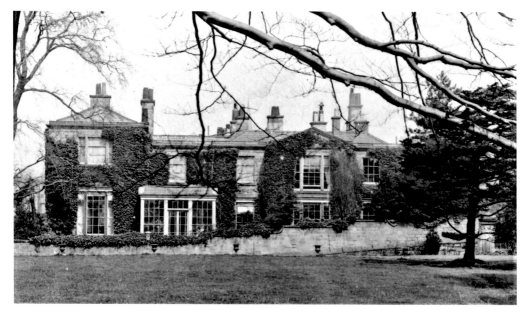

A postcard view of the south front, *c.* 1905. (James Darwin)

several of the family's mills and Bridge Hill House (qv). In 1809 he designed Green Hall near the top of King Street in the town for his nephew, Jedediah Jr. In a nondescript classical style, it was hardly William's best effort, and in 1930 the family sold it and it became flats. The last tenant moved out in 1956 and two years later the site was cleared and the grounds developed.

75. SPONDON HALL (LGIII), 1958

Private, housing estate
Spondon Hall, like Barrow Hall, was a work by Alderman Leaper, built for vintner and lead trader Roger Cox in 1810, a typical stuccoed Regency villa in a pretty park.

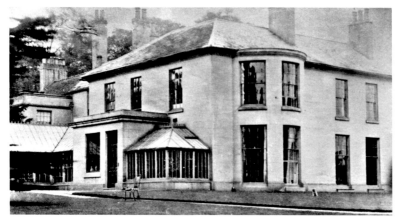

Spondon Hall from the south-west. Photograph by Richard Keene in the 1870s. (M. Craven)

It was sold by the family eventually to the Midland Railway, and after the First World War it became the home of *Royal Scot* designer Sir Henry Fowler, chief mechanical engineer of the LMS, who died there in 1938. It thereupon lay derelict for twenty years before being demolished. The park was offered to the council as a public open space, an offer that was refused and instead the site became a council estate.

76. ASHBOURNE HALL (LGII), 1958

Private

1958 was a disastrous year for Derbyshire country houses; a fourth casualty was Ashbourne Hall, anciently the seat and estate of the Cokayne family, although they had run out of money after the Civil War (through supporting the king) and Sir Aston Cokayne sold to the Boothbys in 1671. In around 1790, Sir Brooke Boothby, 6th Baronet, an Enlightenment figure *par excellence,* rebuilt the old house, the work attributable to Thomas Gardner of Uttoxeter and incorporating some elements of its predecessor. The Boothbys sold up in 1846, after which it had a chequered career, ending the century as an hotel, whose owner, R. Holland eventually closed it and let the house to the Boissiers. In the end it was divided as flats, but the owners gave up the unequal struggle and demolished all but the entrance range in 1958–59. The surviving portion has been restored as offices.

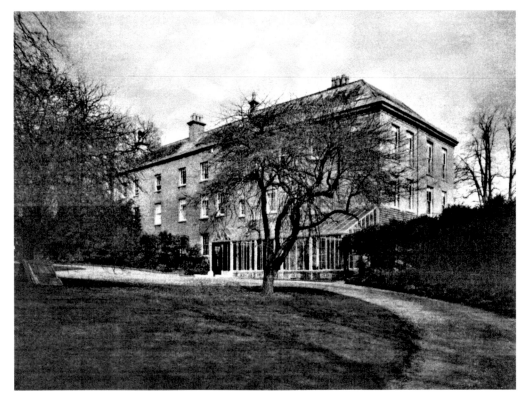

The house photographed from the south-east by Richard Keene, *c.* 1870. (George Cash)

7

Losses 1960–2006

77. NORBURY HALL, 1960

Private

In 1871 Lord Stafford, the head of the FitzHerbert family, who had lived at Norbury since the twelfth century, sold the estate to Samuel Clowes, a Lancastrian cotton spinner. He retained the old manor house, which was converted as a farm and built a new house on the site of the Georgian rectory, using Giles & Brookhouse of Derby, the construction being done in 1873–74. It was a rather large house of brick with banding of Keuper sandstone and a long south front of nine irregular bays, the south-west angle being marked with a fine domed conservatory by Messenger of Loughborough. There was a tower to the north-west, a turret with a witch's hat roof to the east and a Gothic porch. The grounds were landscaped by William Barron & Son. By the end of the Second World War it had become a burden, and in 1960 it was demolished and its site re-wilded. The domed conservatory was saved and added to a farmhouse on the estate.

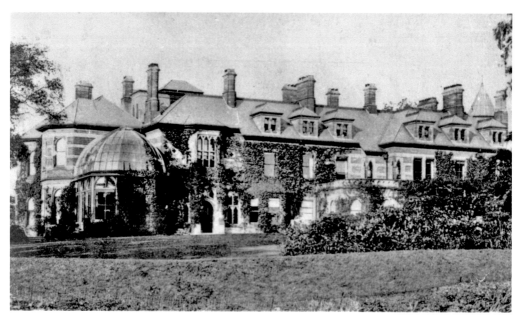

Postcard view of the long south front of the hall at Norbury, *c.* 1905. (M. Craven)

78. DARLEY HALL, DARLEY ABBEY (LGII*), 1962

Public park

There had been a hall at Darley since the county's largest abbey there was dissolved in 1539. The estate was acquired from the Allestreys in 1708 by London merchant William Woolley for whom Francis Smith of Warwick designed a new house, completed in 1727. It was enlarged in 1778 by Joseph Pickford of Derby for a new owner, Robert Holden, for whom William Emes landscaped the park, which is embellished by the Derwent. The Holdens sold in 1835 to the owner of the mills in the village, Samuel Evans, for whom Moses Wood of Nottingham made further alterations. The widow of the last Evans died in 1929 and her heir offered the house and 44 acres of park to Derby Corporation, who bought a further 16 acres. After twenty-four years, the school which had occupied the house moved out in 1958 and in 1962 the house was wantonly destroyed. One room remains as a café, as well as the intact stable block.

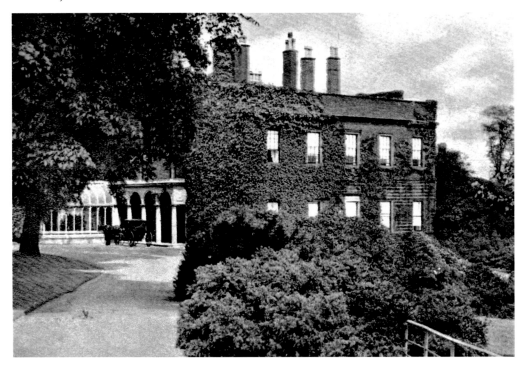

Darley Hall from the south-west, from a lithographic postcard dated 1909. (M. Craven)

79. ALDERCAR PARK, HEANOR (LGIII), 1962

Private

A short-lived house on an estate once part of the parkland of Codnor Castle (qv) on which Thomas Burton built a 'pretty commodious house' in 1668, but which had numerous owners between 1705 and 1848 when it was sold to the

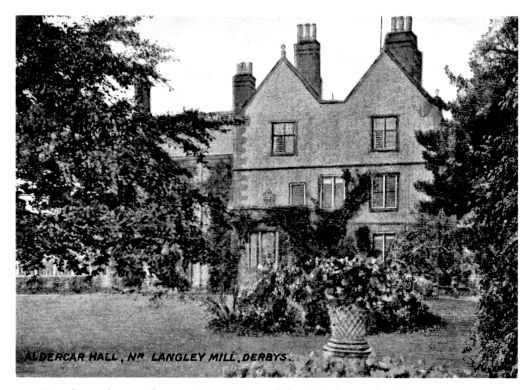

ALDERCAR HALL, N^R LANGLEY MILL, DERBYS.

West front, showing the surviving portions of the 1668 house, the Edwardian wing to the left, and the garden, which boasted a fine lake. From a colour lithographic postcard. (M. Craven)

Butterley Company, which passed it on to director Francis Wright of Osmaston (qv). In 1897 his younger son Arthur FitzHerbert Wright rebuilt and enlarged the house, to the designs of J. R. Naylor of Derby, in the grandest Edwardian style. The grounds were by William Barron & Sons. Yet, by 1927 it was empty and used sporadically by the Butterley Company until demolished by the nationalised industry in 1962. Part of the land was sold in the 1970s and a new house has since been built.

80. LITTLE CHESTER MANOR, DERBY (LGIII), 1964

Private housing

Originally a timber-framed house built on top of a Roman cellar in late Tudor times by a tenant of the Corporation who was granted the former prebendal site in 1555, it was acquired by Robert Hope in 1648 and rebuilt in brick. By 1721 Walter Lord had it, enlarged it, and from whom it descended via Joseph Ward to Dr John Meynell of Meynell Langley, whose son, Godfrey, was born there 1779. Tenanted from *c*. 1810, it was reduced in 1876 and sold to Sir John ('Brassy') Smith in 1886, who divided both land and house in 1896. By the 1950s it was

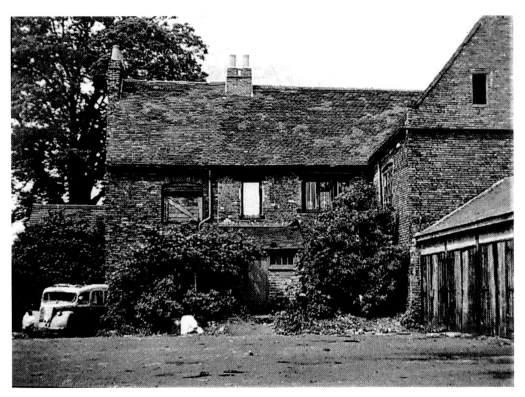

The rear (south) elevation of the manor house, anciently one of seven prebendal farms belonging to All Saints Church, Derby, photographed in decay by the late Roy Hughes, September 1964. (M. Craven)

vacant, and was demolished in 1964 by the council (who filled the cellar with concrete), so the land could be sold for housing.

81. MARKEATON HALL (LGII), 1964

Public park

Anciently the seat of the Touchet family, Lords Audley and Earls of Castlehaven, the Mundys bought the estate in 1516 and built a new Tudor house, itself replaced by Wrightson Mundy in 1755 by a Palladian house designed by James Denstone of Derby and later embellished with orangery and hunting stables by Joseph Pickford in 1772 for F. N. C. Mundy. William Emes landscaped the 123-acre park in 1760–63. Given to Derby Corporation in 1929, who purchased the remaining park, wartime army damage and radical indifference led to its unforgivable demolition in 1964, along with two thirds of the stable block, too. The park remains, much appreciated and well frequented, embellished as an eye-catcher by the house's Regency portico.

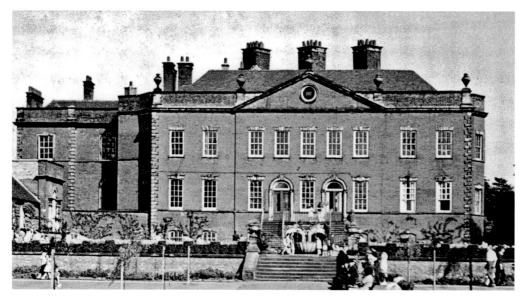

The garden front in 1962, from a slide taken by the late Edward Saunders. (M. Craven)

82. SUTTON ROCK, SUTTON SCARSDALE, 1964

Private

A four-square Victorian house of 1848–1850 built by the Sutton Scarsdale estate (qv) for a younger son of Robert Arkwright, but from 1874 occupied by Robert's daughter, married to William Thornhill Blois, for whom the house was enlarged. Thereafter, it became the residence of the estate's agent, and in 1919 was sold to the Duke of Devonshire as a residence for his own agent, of whom the last

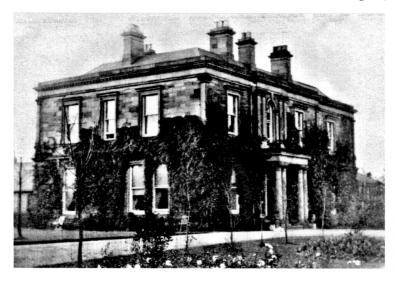

The house
in its heyday
photographed from
the south-west.
(M. Craven)

there was the late Hugo Read CBE, who moved back to Edensor in 1950, when it was sold to the British Coal Board, which cleared it in 1964 in advance of open-casting.

83. DENBY OLD HALL (LGII*), 1966

Private, industrial

Open-cast mining also put paid to another house in this same year, but a much more interesting one. The part on the right in the picture was built after 1563 by Jasper Lowe, but the newer part, originally three storeys, was added to it by Thomas Robey after 1656, who clearly intended to extend it symmetrically in the style of John Smythson to include the old gabled part, but never did. It passed to the Strelleys but in 1763 became a tenanted farm and was reduced to two storeys. The Lowes (as, ultimately, Drury-Lowes) got it back and it was latterly converted into miners' cottages, but fell empty after nationalisation in 1948 and was unceremoniously cleared in January 1966.

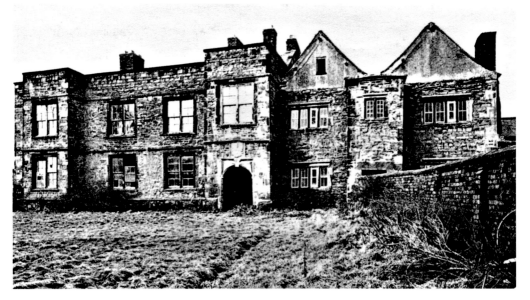

Denby Old Hall entrance front photographed by the late Roy Hughes, January 1966. (M. Craven)

84. OSMASTON MANOR, OSMASTON-BY-ASHBOURNE (LGII), 1965

Private estate

Something of a prodigy house, built in 1846–49 for super-rich Francis Wright, banker and proprietor of the Butterley Company, to designs of Henry Isaac Stevens of Derby in carboniferous limestone ashlar with an extensive 3,500-acre park laid out by Sir Joseph Paxton. Despite selling the estate to Sir Andrew Barclay Walker, 1st Baronet, in 1884, the Wrights had changed their name to Osmaston. Walker

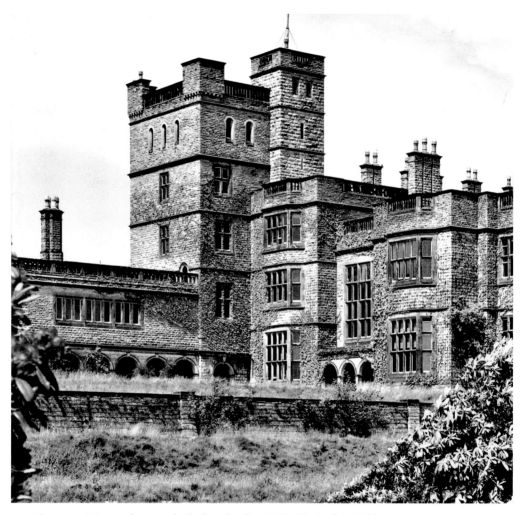

Osmaston Manor, photographed when derelict, 1964. (*Derbyshire Life*)

made some additions and undertook much interior redecorating using Sir Ernest George & Peto. The second baronet married the heiress of Okeover, Staffordshire., and his son, Sir Iain Walker-Okeover 3rd Baronett, eventually demolished the house in 1965 and retired to Okeover. The park, with buildings and delightful nearby estate village (mostly by Stevens), are still fully maintained by the family.

85. PARKFIELDS CEDARS, DERBY (LGIII), 1965

Education Authority
Around 1817 banker and prolific amateur architect Richard Leaper (1759–1838) built himself a villa here, later called Parkfields Cedars. His authorship of its

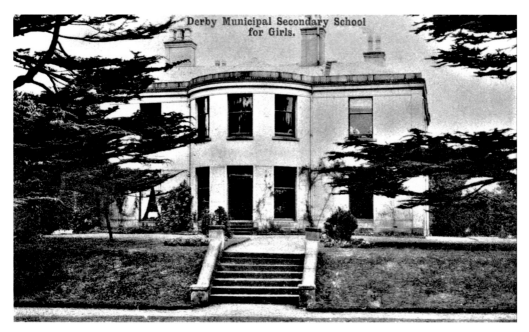

Garden front in 1912, before conversion, from a postcard. (M. Craven)

design is attested by its resemblance to his Barrow Hall, Barrow-on-Trent (qv), and the fact that he resided there during the final two decades of his life. He specialised in neat stuccoed Regency villas and was responsible for more than ten. Inside, the main stair was timber and almost Jacobethan in design, bifurcating at the mezzanine to reach a galleried landing; later this was lit by a thorough-going Gothic window filled with exuberant stained glass. After Leaper's death Alderman John Sandars (Mayor of Derby 1839–40) owned it, followed in 1867 by the Wilmot-Sitwell family, who 1905 sold it to Derby Corporation with 5.5 acres for £5,800. They converted it into a girls' grammar school, which opened in 1917. It was completely gutted by fire 6th February 1965 and was subsequently demolished.

86. ALFRETON HALL (LGII), 1968

Hotel
A four-square house in his typical later style designed by Francis Smith of Warwick for the Morewood family, coal owners, in 1724–26, with 95-acre landscaped park by Edward Outram, grandfather of the engineer, which partly survives. The Palmer-Morewoods succeeded in 1796, and later tactfully extended the house in matching style and added an Ionic portico but, in 1855, a much larger wing was added to the south front to a clunky design by Benjamin Wilson of Derby, which almost doubled the size of the house. Sold with the

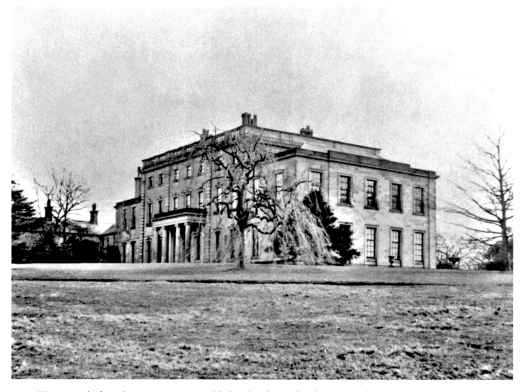

West view, before the extension was added, taken by Richard Keene, February 1855. (M. Craven)

park to the county council in 1957, it moved on in 1964 to Alfreton UDC, who sold 523 acres for redevelopment and, alleging colliery subsidence, demolished most of the house in 1968, leaving only the 1855 wing, now a hotel set in a public park.

87. SHALLCROSS HALL, WHALEY BRIDGE (LGII), 1968

Housing
In 1723–25 John Shalcross (*sic*), whose family had lived on the site since the thirteenth century, built a new classical house, the design cribbed, probably by a local builder, from Francis Smith's largely unbuilt Clifton Camville, although it was once attributed to James Gibbs. The interior with its Vanburgh-esque hall screen included two rooms fitted out with oak panelling from the previous house. On Shalcross's death it passed to the Jacsons of Bebington and then to the Fosters and the Bowers before being acquired by the Jodrells of Yeardsley. From 1850 it was the seat of the Hall family, who eventually sold to Buxton Lime Firms (later ICI), which wrecked the setting before selling the house to the local council. Long derelict, it was demolished in 1968 to make way for a small housing development.

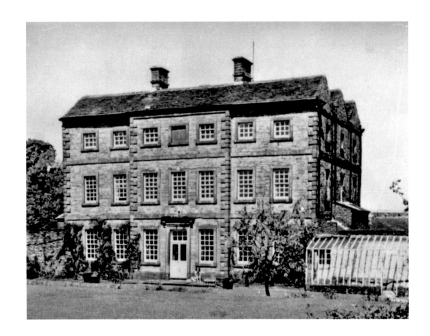

Garden front,
c. 1935.
(J. Darwin)

88. PILSLEY OLD HALL (LGII*), 1969

Housing

The d'Eyncourts of nearby Park Hall were the original owners of the estate and their successors, the Busseys, sold to the Leakes of Sutton Scarsdale in 1581, who appear to have built a modest house, parts of which were incorporated in

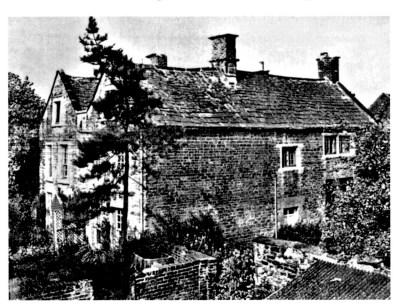

The house in
decay, seen
from the east,
1969. (Private
collection)

a rebuild in the 1690s, which endowed it with a new façade with sash windows. It was sold to Richard Calton of Chesterfield 1736 and to Thomas Wilson in 1799, who undertook some modernisations including a new staircase. It eventually came to the Sampson family, who sold to F. Gardner, who demolished it in 1969.

89. BREADSALL MOUNT, 1970

Housing

In 1863, Thomas Osborne Bateman of Hartington Hall found that his Derby villa in Osmaston Road was becoming too noisy from nearby foundries and commissioned Henry Isaac Stevens to build him a new one, further out of town. Breadsall Mount, the stone-built Jacobethan result, was built on a ridge on the edge of Breadsall. The family lived there (with occasional periods when it was let) until 1929, when it was purchased by the new diocese of Derby for their first bishop, Dr Courtenay Pearce, to live in. His arms, impaling those of the diocese, were accordingly carved over the entrance. In 1968, it was considered too grand for the go-ahead bishop of the day, who was shunted off to a smaller villa in Turnditch, and the house was sold to Derby Corporation. Needless to say, they soon demolished it, covering the site and small park with municipal housing.

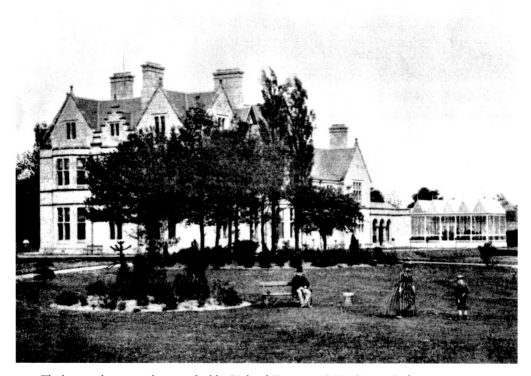

The house when new, photographed by Richard Keene, *c.* 1866. (George Cash)

Bishop Pearce's arms impaled by those of the new diocese of Derby, carved in 1927 over the entrance, photographed in 1969. (Late R. G. Hughes)

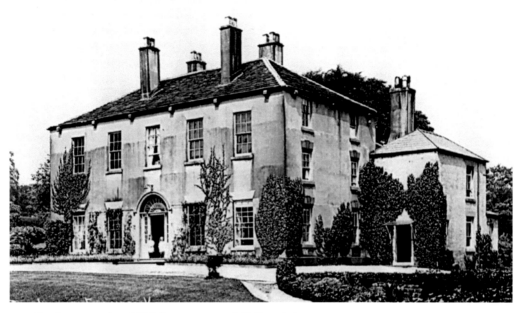

South-eastern view, 1935, from a postcard. (J. Darwin)

90. FURNESS LODGE, WHALEY BRIDGE (LGII), 1971

Housing

An elegant brick house of two and a half storeys, later stuccoed, situated high up above Furness Vale, Dinting. It has a superb side-lit doorcase with octagonal panels to the door and a filigree fanlight above, very stylish for Derbyshire. Built 1794 by the owners of calico printing mill nearby, the freehold was attached to the ownership of the mill itself. The Saxby family, proprietors of the mill, were in occupation from 1850s to 1880s. Long derelict and overgrown with bocage when recorded by RCHM (E) in 1971, it was demolished soon after for a housing estate.

91. STAINSBY HOUSE, SMALLEY (LGII), 1972

Replaced

There was an early eighteenth-century villa here, built by the coal-owning Fletcher family who acquired the estate from the Moors (*sic*). John Fletcher's daughter married Francis Barber of Greasley, Nottinghamshire, and in 1780 Thomas Gardner of Uttoxeter enlarged it vastly. The son sold to Edward Sacheverell Wilmot, whose son further enlarged the house in 1837. In later years it became a poultry farm and then a Catholic school, before being bought by R. Morley, who demolished it and commissioned a striking new house from David Shelley of Nottingham.

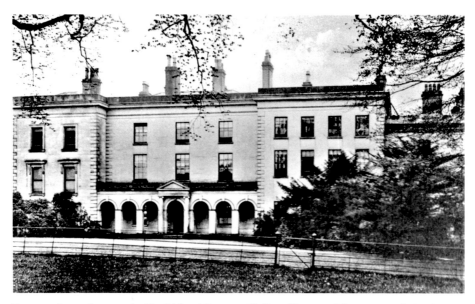

Entrance front, photographed by Richard Keene, *c.* 1865, and later used for a postcard. (M. Craven)

92. OAK HURST, ALDERWASLEY, 1975

Private, ruinous

The Hurt family of Alderwasley founded an ironworks in the Derwent Valley below and in 1848 a substantial stone house was built by the lessees of the

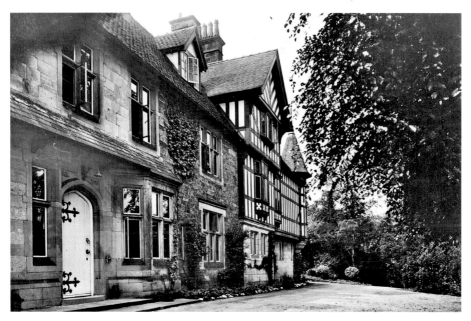

The east front when in use as a retreat house, from a postcard dated 1924. (M. Craven)

works John & Charles Mold. The Midland Railway bought it in 1865 and their architect, Charles Trubshaw, enlarged it in 1888. Shortly afterwards it was acquired with the works by John Thewlis Johnson and it was rebuilt in a robust Arts and Crafts style probably by John Douglas of Chester. In 1924 it became a diocesan Retreat House, was converted into flats in 1945, but in 1975 it was abandoned, eventually becoming a total ruin, deep in private woodland.

93. POTLOCK HOUSE, FINDERN (LGII), 1982

Private land

Potlock is a deserted medieval village near the Trent with a (vanished) church and a manor house which was inherited in the sixteenth century by the Harpurs of Swarkestone from the Finderne family. They reduced it and converted the remaining part into a farmhouse. This was acquired by John Glover in 1805, who removed most of the medieval parts, but incorporated a fragment into a delightful Regency villa set in a small park. Post-war, with a power station looming over it, it again became a farm but was bought in 1981 and later demolished by Messrs. Amey Roadstone for the gravel beneath it. This, however, has yet to be extracted – a pointless piece of wanton destruction.

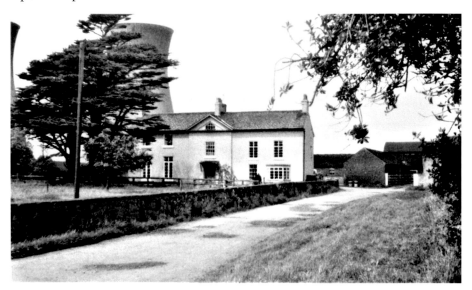

Potlock House, when still a working farm, 1981. (M. Craven)

94. STUFFYNWOOD HALL, SHIREBROOK, 1988

Private land

The original seat here started out as a farmhouse, but in 1858 Robert Malkin replaced it with a villa in coal measures sandstone. This was later

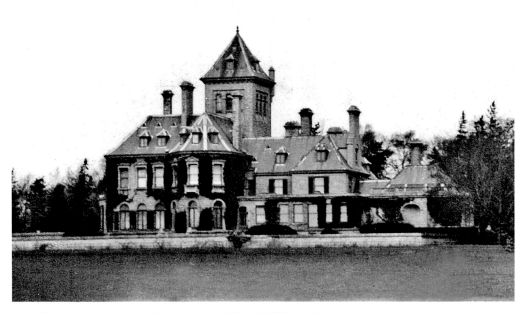

The house at its zenith, from a postcard dated 1907. (M. Craven)

acquired with a considerable estate in Pleasley Park by Charles Paget in 1861 and his son Joseph inherited in 1873 and enlarged the house to include an exceedingly sturdy tower and landscaped the grounds. It was sold in 1915 to the Markhams of Chesterfield, but was unoccupied for many years before being requisitioned in 1939. Thereafter it lay increasingly derelict, before being reduced to a manageable size in 1979 but, finding no takers, was finally cleared in 1988.

95. BURNASTON HOUSE (LGII), 1990

Car factory

Burnaston House was a particularly fine regency villa built to replace a farm called Conygree Hall of Keuper sandstone in 1824 for Ashton Nicholas Every Mosley to the designs of Derby amateur Richard Leaper, aided by Samuel Brown. It was inherited by Col Godfrey Mosley of Calke Abbey, who sold it in 1936 to Derby Corporation to act as the clubhouse and terminal of Derby Aerodrome, opened in 1938. This was closed to international flights in 1968 and the house became semi-derelict until bought in 1987 for restoration as a care home with an English Heritage grant. Politics then intervened, and the county council compulsorily purchased the site for Toyota to erect a car factory. The building was never de-listed and was dismantled carefully by developer Kevin Ellis, whose efforts to re-erect it elsewhere have been constantly thwarted by local bureaucrats.

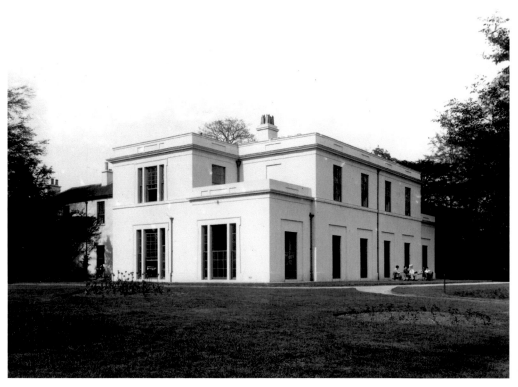

The house as converted to a clubhouse and airline terminal, 10 May 1939, photographed for the Corporation by Hurst & Wallace of Derby. (M. Craven)

96. MILL HILL HOUSE, DERBY (Local list), 2006

Mosque car park

An architecturally important villa built by Thomas Ward Swinburne on one of the highest parts of Derby between 1810 and 1814, the architect being his cousin, Alderman Richard Leaper (1759–1838). Leaper, influenced by locally born connoisseur Sir William Gell, was attempting to build something approaching the ideal (ancient) Greek house, the result being a severely plain rectangular box of a house with grooved stucco. Later residents included Thomas Parker Bainbrigge and Derby Mayor Alderman John Renals, who installed Robert Bakewell's gates from the west entrance of Derby Cathedral, liberated by road widening. The extensive park was reduced by the demands of industry early on and vanished entirely in Renals' time. After 1918 a third was demolished and the remainder was for eighty years a Catholic club. It was refused listing, bought and demolished in February 2006 for the site of a vast new mosque, but promised funds from Saudi Arabia failed to materialise and it was not built, the adjacent Christadelphian chapel being converted instead.

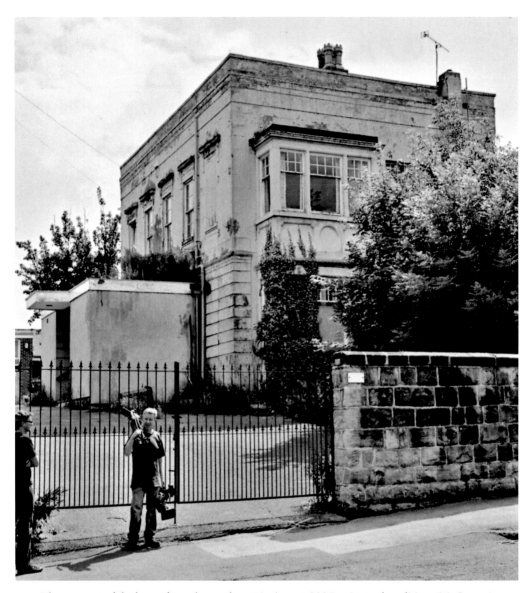

The remnant of the house from the north-east in August 2005, prior to demolition. (M. Craven)

97. THORNHILL, DERBY (Local list), 2006

Housing
Another Regency villa by Alderman Leaper, built on more conventional lines between 1820 and 1821 for £7,000 for Major John Trowell, who died before he could live in it. In 1873 it was sold to 1st Lord Belper, who sold 23 acres of park to build Derby Lunatic Asylum, but let the house to the unmarried daughter of

A. N. E. Mosley of Burnaston House. It was later also sold to the Corporation and infelicitously rebuilt as an extension to the asylum, before becoming redundant in 2003 and boarded up. The site was sold to a quango, English Partnerships, which demolished it in August 2006 for sale to a housing developer.

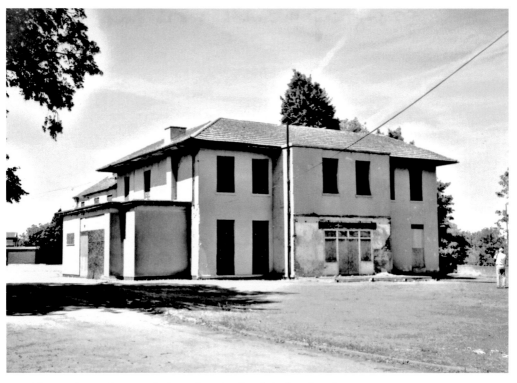

The east front, photographed in July 2006 shortly before demolition. (M. Craven)